CONTEMPORARY KOGIN-ZASHI

Modern Sashiko Beyond Filling in the Gaps

Shannon and Jason

stashBOOKS.

an imprint of C&T Publishing

Publisher: Amy Barrett-Daffin

Creative Director: Gailen Runge

Senior Editor: Roxane Cerda

Editors: Karla Menaugh and Liz Aneloski

Technical Editor: Kristyne Czepuryk

Cover/Book Designer: April Mostek

Production Coordinator: Tim Manibusan

Illustrator: Kristyne Czepuryk

Photography Coordinator: Lauren Herberg

Photography Assistant: Gabriel Martinez

Front cover photography by Jason Bowlsby

Photography by Jason Bowlsby, unless otherwise noted

Published by Stash Books, an imprint of C&T Publishing, Inc., P.O. Box 1456, Lafayette, CA 94549

Library of Congress Cataloging-in-Publication Data

Names: Roudhán, Shannon Leigh, 1967- author. | Bowlsby, Jason, 1970- author.
Title: Contemporary kogin-zashi : modern sashiko beyond filling in the gaps / Shannon & Jason.
Description: Lafayette, CA : Stash Books, an imprint of C&T Publishing, Inc., [2022] | Includes bibliographical references. | Summary: "Using their side-by-side method of teaching, Shannon and Jason use detailed photography and step-by-step written and graphic instructions to help you create your own stunning projects using Kogin-zashi stitching. Alongside a robust stitch library readers will find 10 projects to showcase their Kogin-zashi work"-- Provided by publisher"-- Provided by publisher.
Identifiers: LCCN 2022027231 | ISBN 9781644031872 (trade paperback) | ISBN 9781644031889 (ebook)
Subjects: LCSH: Sashiko. | Embroidery--Japan.
Classification: LCC TT835 .R676 2022 | DDC 746.440952--dc23/eng/20220810
LC record available at https://lccn.loc.gov/2022027231

Printed in China

10 9 8 7 6 5 4 3 2 1

DEDICATION

This book is dedicated to, and honors, all those whose hands created kogin-zashi out of a need for survival, and for those who preserved their work and passed on their skills so that we might now discover, explore, and learn to stitch new kogin-zashi pieces out of the joy of creative expression.

ACKNOWLEDGMENTS

We would like to take a moment to say thank you to all of the folx who have shared their knowledge of kogin-zashi with us via their books, their teachings, and through exhibitions of their work.

Special thanks to the folx at the Seattle Art Museum, Elisabeth Smith (Collection and Provenance Associate) and Marta Pinto-Llorca (Senior Collections Care Manager), for allowing us supervised access to the museum's collection of sashiko. Seeing these pieces up close was invaluable to our learning and sent us down even more rabbit holes.

Super special thanks to Maiko Ishida—kogin-zashi author, editor, and curator of an amazing collection of her grandmother, Akiko Ishida's, kogin pieces. Thank you for always answering our messages despite the language gap. Your and your grandmother's work continues to inspire us, and your resources and referrals to others' kogin work mean everything to us.

Finally, thank you, thank you, thank you to all of you: the folx who have come down the rabbit holes with us these past few years and, particularly, this past year. It means the world to us to pass on our knowledge and joy, and to see you all, in turn, experience your own creative joy. Thank you for making it possible for us to do what we love.

Contents

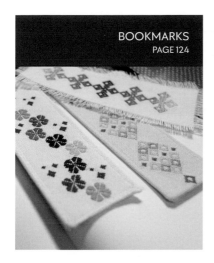
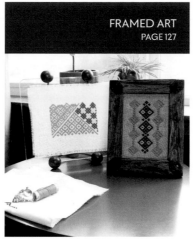
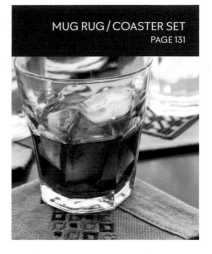
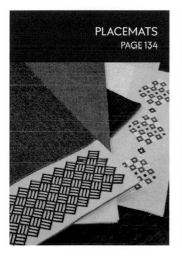
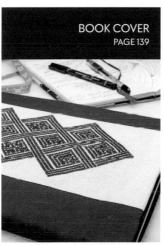
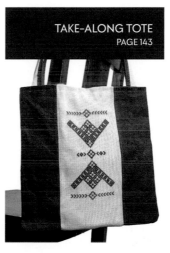
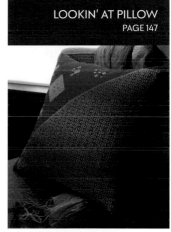
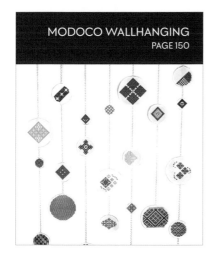
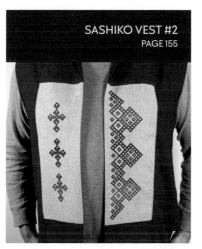
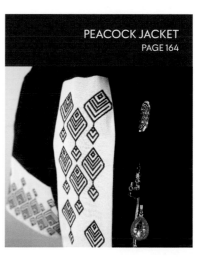

A WORD (OR TWO)
from the Authors

Welcome to the rabbit hole. This journey into the complex, beautiful, and enthralling world of boro and sashiko has, once again, taken a turn down yet another path. With this, our second book of sashiko projects, we explore kogin—the counted-thread branch of the sashiko rabbit hole. Thank you for continuing this exploration with us …. As always, we have a few things to say before we commence with this leg of our journey.

Quick and Easy

We are, as a general rule, disinclined to use the catch-all phrase "quick and easy" as a descriptor for anything other than instant pudding or home hair dye. There has been an ongoing effort to market craft projects as such, and the result is the alienation of those for whom those projects are neither quick nor easy. What might seem easy for one certainly cannot be deemed so for another since every person comes from a different background and has a different skill set which might make origami swans quick and easy or an engineering nightmare. Also, quick and easy implies that anyone who does not find said project quick and easy is lacking in some way, either in skills or general adeptness. Any of these are assumptions at best and insulting at worst.

Additionally, the quick-and-easy moniker erases any acknowledgment of handcrafts and art that actually take time to create or that, hey, maybe some of us actually like to slow down and lose ourselves in the process. We wish to avoid any such injury to you, the maker, and fully recognize and celebrate that some craft just takes time and that makers like taking that time. Therefore, we will not, at any time, slap a label of quick and easy on any of the projects in this book. They take the time they take. No more. No less. And that's just fine.

Relax and enjoy the process.

This book is meant not to be the definitive guide to all things kogin-zashi, but, instead, to be a book of projects that use kogin-zashi as their medium.

The history and backstory of kogin-zashi are as rich and complex as the people whose hands created the distinct stitch patterns. Why the Japanese people used this form of darning-style stitching to reinforce and beautify their fabrics is well documented through the work of the *Hirosaki Kogin Institute, the Koginbank*, and through authors and teachers like Maiko Ishita and Akiko Ishita. It is their work and the work of others that we have studied and sought to understand so that we could integrate this compelling needlecraft into our own work and art while honoring their knowledge, skills, and the history of the Japanese people who developed this form of darned needlework. It is our interpretation and expression of kogin-zashi that we share with you in the pages of this book. Here on these pages, we are expressing our creativity and design esthetic using kogin-zashi as our medium in the hopes that you too will be as enthralled and compelled as we were when we first encountered the rich textiles of Tsugaru kogin-zashi sashiko.

- - - - - - - - - - - - - - - - -

THE STITCHER'S PROMISE

Raise your needle and repeat:

I, [insert your name here], do promise to be patient with myself, to not judge my work harshly, and to give myself the grace and permission to learn something new. I promise to remind myself of the *fact* that every new skill has a learning curve that everyone must go through, regardless of how accomplished they are at other skills.

- - - - - - - - - - - - - - - - -

A LITTLE CONTEXT
for the Content

WHAT'S IN A NAME?

KOGIN = small cloth • ZASHI = small stitches

Origins

Like hitomezashi and moyouzashi, the forms of sashiko we covered in *Boro & Sashiko: Harmonious Imperfection*, kogin-zashi was created by Japanese folx who, living in cold climates with short growing seasons, needed to reinforce and fortify fabric for survival.

At the time kogin-zashi was developed (Edo Period, 1603–1867), cotton was a scarce commodity due to the short growing season and the overall cold climate of the Tsugaru region, Aomori, Japan—kogin-zashi's area of origin. In addition to the scarcity, cotton was forbidden for garment fabric by anyone but the ruling class in Japan. Unfortunately, this meant folx had to make do with fibers made from plants like ramie, hemp, and tree barks to weave their cloth. Unlike cotton fabric, such fabric does not offer optimal protection from the elements and layering did not provide the needed protection either.

Being resourceful and downright clever, they used kogin stitches made with cotton thread to fill in the gaps in the hand-woven fabric. Filling in the gaps created a denser fabric that provided protection and much-needed warmth while skirting the strict laws regarding cotton's use in garment fabric. Kogin fabric is inherently practical because it provides added warmth and reinforcement from the stitches, but it is also a work of art—as so many other handwork necessities are seen after the passage of time. Fabrics with kogin stitching are complex and dense and contain patterns from basic borders and lines to intricate key forms and tiled marvels of design. Through the lens of time, this practical handwork task has become art and the craft we love today.

■ What Is Kogin-zashi?

Kogin-zashi is a type of darned embroidery, meaning the stitches lay closely against one another in horizontal lines to reinforce and enhance the base fabric. Kogin is a type of counted thread work with a shared DNA evident in other forms of darned embroidery, counted threadwork, pattern darning, and needle weaving from Norway, Yugoslavia, and Ukraine, Medieval Middle Eastern counted thread embroidery, and Mamluk pattern darning found in the Middle East and Egypt.

Kogin-zashi designs are created by counting the vertical threads of the base fabric and working the needle over and under those threads, following the space between the horizontal threads of the base fabric. The stitches are worked into the spaces created by the intersection of the horizontal (warp) and vertical (weft) threads, truly filling in the gaps in the woven fabric.

Although modern kogin stitchers are starting to use threads running both vertically and horizontally to create dynamic designs, traditional kogin-zashi patterns are made using running stitches that are worked only in horizontal lines. Our patterns found in this book follow this tradition.

The needle is worked over and under the vertical threads of the base fabric while following the space between two horizontal threads. Each subsequent row is worked directly

above or below the previous row so that the kogin pattern is revealed one line of stitches at a time. Remember how we used to print photos on a dot matrix printer? Like that. (Bonus points if you understood that dated reference!)

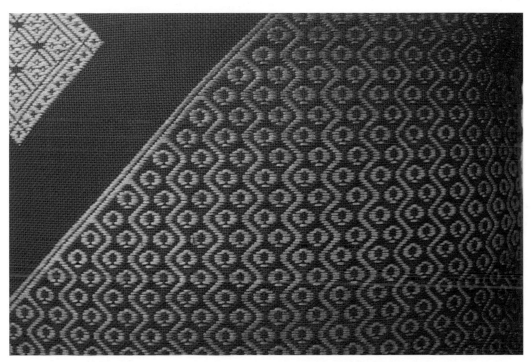

Lookin' at Pillow *(page 147)*

LOCATION, LOCATION, LOCATION

In the 20th century, kogin-zashi underwent a standardization that established the types of kogin based on their area of origin. Those are Nishi-kogin, Higashi-kogin, and Mishima-kogin—all originating from the Tsugaru region in the northern part of Honshu Island, Japan. Nishi-kogin originates from the area west of the Iwaki River, Higashi-kogin from east of the Iwaki River, and Mishima-kogin from the delta area of the Iwaki River. These three types can be confirmed in this illustration by Sadahiko Hibino from 1788.

Kogin–zashi types illustrated by Sadahiko Hibino, 1788

Photo by: Public domain via Wikimedia Commons

Most sources also recognize a more general distinction between Tsugaru kogin-zashi and Nanbu hishi-zashi. Tsugaru, from the Tsugaru region, is the overwhelming style we use in this book and is characterized by stitches that shift each row by one thread, giving the finished patterns a symmetrical shape that covers the same number of threads both vertically and horizontally. Nanbu hishi-zashi utilizes shifts of two threads in each row, giving hishi-zashi patterns an elongated diamond shape.

Tsugaru kogin–zashi

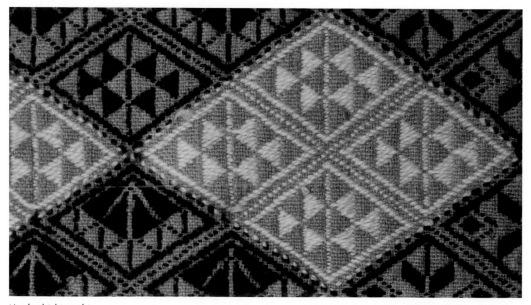

Nanbu hishi–zashi
Photo courtesy of Seattle Art Museum

▌ DEVELOPMENT AND PROMOTION

Kogin being recognized as a valuable craft and art form can largely be attributed to the makers who passed on their knowledge for generations, but the modern driving force and knowledge base has come from the Hirosaki Kogin Institute. As early as 1942, the Hirosaki Kogin Institute has been collecting, cataloging, and promoting kogin-zashi. Their first director, Yokoshima Naomich, wrote the seminal work *Tsugaru Kogin* in 1974 which is still regarded as the authority on traditional kogin-zashi.

Today, the work of the institute as well as modern makers and authorities continues to preserve, develop, and pass along the craft of kogin-zashi. Akiko Ishida, who collected and developed kogin patterns, and her granddaughter Maiko Ishida have authored a book and mounted exhibits of kogin that are invaluable to researchers and fans of kogin alike.

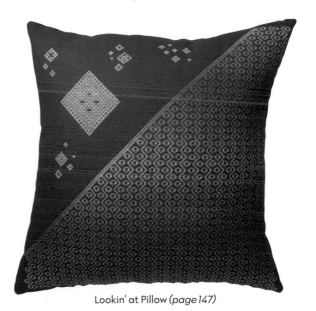

Lookin' at Pillow (*page 147*)

Likewise, Iemasa Yamahata, who presides over kogin.net, and Katsue Ishii, editor-in-chief of Koginbank, provide invaluable resources to those seeking knowledge and the history of kogin. In addition to being a kogin artist and author, Maiko Ishida is a member of the editorial board of the magazine *Sorutobu-kogin*, whose editor-in-chief, Sanae Suzuki, leads the magazine in covering traditional and developing kogin artists and makers. We encourage you to take advantage of these valuable resources to learn more about the fascinating history and development of kogin-zashi.

And that, friends, brings us to this very moment. You are holding in your hands a portion of our body of work that seeks to further honor the traditions of kogin by thirstily internalizing the work and knowledge passed on to us by those who came before through their writings, photographs, and words. Our fervent hope is that, in turning that wellspring of knowledge into our own creative pieces, we will inspire you to learn about, appreciate, and honor the long and vibrant history of kogin-zashi.

The Supplies

Tools

The best feature of sashiko in general, and most certainly kogin-zashi is the accessibility. You don't need access to a lot of expensive sewing equipment to create a beautiful piece of kogin fabric. Once you have the fabric cut, you need only a needle, thread snips, kogin needle, and your thread or floss. That said, here is a complete list of the tools we find indispensable. Most are relatively easy to find in your local craft store or even on our website at shannonandjason.com.

Needles and Notions

KOGIN SASHIKO NEEDLE

A kogin-zashi needle has a large eye, long shaft, and is different from a needle used for hitomezashi or moyouzashi because the tip is blunt, allowing for picking up and working between the threads of evenweave fabric without piercing the threads themselves.

SASHIKO NEEDLE

This needle is similar to a kogin sashiko, but with a much sharper tip for working with extra-fine fabrics to easily manipulate between the warp and weft threads, which are often more difficult to see.

THIMBLE WITH PALM PLATE

We use a Clover thimble with a palm plate, an adjustable ring that you place on your middle finger with the disc laying against your palm.

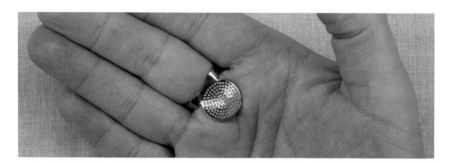

THREAD SNIPS

Gotta have a great pair of sharp thread snips close at hand. These Clover Kuroha thread snips are in every project bag and on every work surface around our studio and workspaces.

FABRIC SCISSORS

A sharp pair of sturdy fabric scissors is at the center of every fabric worker's tool kit. Often labeled with "FABRIC ONLY" or "DO NOT TOUCH THIS MEANS YOU," good fabric scissors make every cutting job easier. Wipe them clean and take them for sharpening regularly, and you will have an heirloom that future makers will cherish.

▌ GOOD LIGHTING

Even on the brightest days when we are working in a window seat, having a clear, bright light like our Daylight Company Slimline 3 makes our stitching much easier and enjoyable.

▌ MAGNIFIERS

We cannot stress strongly enough how useful it is to have a good magnifier lamp. Some fabrics with a lower thread count are fine for working with the naked eye, but we find our stitching goes much faster and is more accurate with a good magnifier and clear lighting like that from our Daylight Company Omega 3.5.

▌ HAND SEWING NEEDLE

Hand sewing needles are a must for finishing the edges of fabrics and general sewing.

Hand-Sewing Thread

For our hand sewing and the projects in this book, we typically use Aurifil 50-weight cotton thread.

RULERS AND TAILOR'S TAPE

A supply of good rulers and tailor's tapes are needed for all the projects in this book.

Marking Supplies

MARKING PENS

Always test your fabrics before marking them to ensure your marking tools don't damage, stain, or permanently mark your fabric. Here is a list of our favorites, always kept close at hand.

CLOVER WHITE MARKING PEN

A Clover white marking pen is great for marking on darker fabric and disappears quickly with heat from an iron.

White Marking Pen 〈Fine〉 CLOVER

CLOVER BLUE MARKING PEN

The Clover blue marking pen works like a charm on light-colored fabric and rough, textured fabrics and washes out with water.

CRAYOLA WASHABLE MARKERS

We use Crayola washable markers for marking pattern fabric, taking notes on pattern pieces, and marking the type and thread count of our fabric pieces in the seam allowances.

Pro Tip: Test Your Fabric

Always test your fabrics before marking them. Most of the above markers will wash out of your fabric with ease … but nonetheless, save yourself a little heartache and test your markers beforehand.

SCHOOL PENCILS

Yup! In a pinch, a good ol' soft pencil will mark fabric just fine. Always test your fabrics because some pencils can stain your fabric. We use them for dark fabrics and for marking notes in the seam allowances of fabric pieces. Oh yeah … you can write on paper with them. We know … paper.

▌ OTHER MARKING TOOLS

A Hera Marker is a must-have if you want to outline a pattern piece or define an area within your project without putting pen to fabric. The Hera Marker creases the fabric by denting the threads, so be mindful of the amount of pressure you use so as to not damage the fabric.

Yes, here's a regular ol' table knife. In a pinch, we have used the dull backside of a table knife to make creases in fabric. Necessity is the mother of invention and all that

Now that we've geeked out on gadgets (we do LOVE a good gadget), let's move on to the complex and rich world of thread and fabric!

▌ Threads

There are many threads on the market called sashiko thread and kogin thread, and we have tried most of them. Different threads work better with different types and counts of fabric, so understanding the threads and anticipating possible issues will result in a better stitching experience and a better finished project. Following are the threads and yarns we use for our personal stitching and for the projects in this book.

Our Favorite Thread Choices

EMBROIDERY FLOSS

Aurifil Cotton Floss is a 6-ply embroidery floss made from tightly spun mercerized cotton, resulting in a smooth thread that does not snag on your fabric easily. It also comes in a gorgeous array of 270 colors so you won't be limited in your creativity. The floss is smooth and separates easily for use in different groupings of plies depending on the thread count of the base fabric. Because of the availability of 6 plies, color blending effects can be incredibly subtle.

Spools of Aurifil Cotton Floss

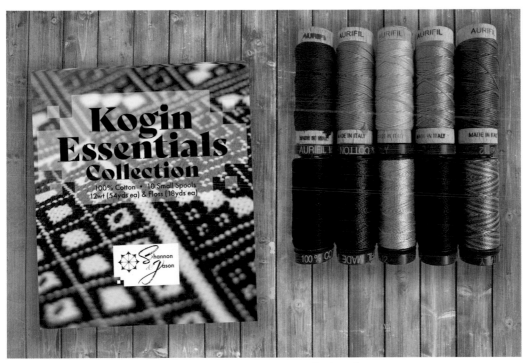

Our Kogin collection for Aurifil, with Aurifil cotton floss and 12–weight thread

Photo courtesy of Aurifil

SASHIKO THREAD—12-WEIGHT

Aurifil 12-weight thread is a 2-ply mercerized cotton thread, so smooth that you don't experience snags while making your stitches and you don't need thread conditioner. It comes in a palette of 270 colors from neutrals and blenders to pastels and intensely vibrant jewel tones. We use Aurifil cotton 12-weight thread for all three forms of sashiko.

Unlike moyouzashi and hitomezashi, we use two or three strands of 12-weight held together depending on the thread count of the fabric. The plies of this thread are not separated as with floss. As you can see in the projects in this book, color blending is remarkably effective using 12-weight thread, especially when the colors are close together on the spectrum or closely related.

Spools of Aurifil 12–weight thread

LACE-WEIGHT YARNS

Although yarn is not used in traditional kogin-zashi, some of the sashiko and kogin thread we purchased from Japan is more like a fingering or lace-weight cotton yarn or a thick cotton thread. Lower-count evenweave like burlap, linden cloth, and other bark-based fabrics work well with yarn to create interesting bags, accessories, and pieces of art. Think plastic grid canvas and outdoor fabrics with yarn for the kogin patterns as outdoor decor and art.

Blue Moon Fiber Arts, Soft Rock yarn

SPECIALTY THREADS

Once we started experimenting, the sky was the limit. We encourage you to experiment with base fabrics and thread alternatives. We have used Kreinik threads, silk thread, hemp, linen thread, and Jelly Yarn.

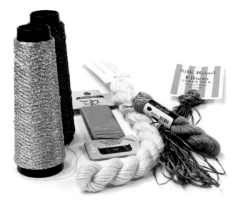

Whatever thread or thread alternative you prefer, it is important to choose your thread based on the count of your base fabric. Your rows of finished stitches should lay neatly alongside one another, and your stitches should not distort the threads of the fabric so much that the overall pattern is lost. Your finished pattern could look full and plump or flat and smooth, depending on your project and what you want it to look like. Once you feel confident using the thread and fabric combos we used in this book, experiment with smaller swatches to discover new combinations that make you happy.

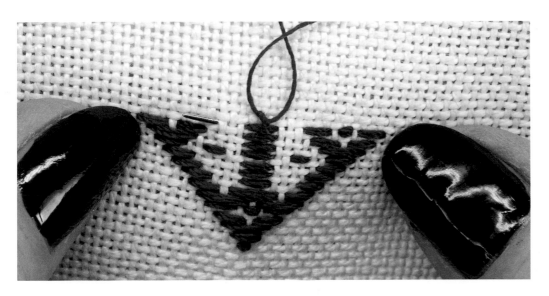

We love thread. Silks, wools, cottons, plastic ... we can't get enough of it ... the colors, the textures! Just ask the folx at Aurifil ... they'll attest to our seemingly unquenchable thirst for MORE color and MORE thread to play with! That said, we love fabric. Like ... love. So let's explore the topic of fabric next.

Fabrics

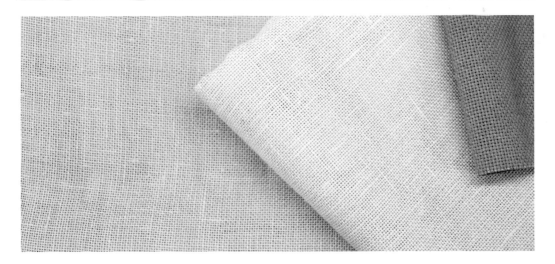

Unlike other forms of sashiko, traditional kogin-zashi is worked on a specific type of cloth called evenweave fabric. While there are several kinds of evenweave on the market to choose from, there are a few factors that must be considered when choosing your fabric for your projects. These factors will ensure that your stitch patterns are proportional and smooth and that the overall pattern fits the piece you are making.

Evenweave Fabric

Evenweave is the most common fabric used for traditional kogin-zashi. As the name implies, the number of threads per inch is the same in the warp and in the weft of evenweave. This even weave ensures that your motifs and overall patterns will be symmetrical and ... well ... even!

Some evenweave examples are Aida, Fiddler's Cloth, Hardanger, Davosa, Lugana, and cork linen. Evenweave can be of any composition (cotton, linen, synthetics, blends) and each has properties that make it appropriate for different projects. For example, Davosa and Lugana are soft and drapey, so they work beautifully for projects that will be next to skin like garments, blankets, and pillows. Congress cloth, on the other hand, holds up more like screening and works great for patches and framed art.

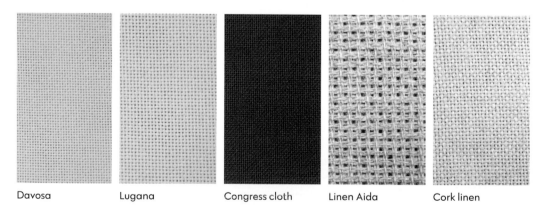

Davosa Lugana Congress cloth Linen Aida Cork linen

Pro Tip: Always Check Your Threads!

Please be aware that not all fabrics are evenweave! Be sure to either check yourself by counting the threads, or order from a site like ours with definitively labeled evenweave fabrics, or from a retailer who knows their embroidery fabric lines well.

THREAD COUNT

In this book, we refer to the evenweave "thread count" meaning the number of threads per inch. In the case of evenweave, the thread count will, of course, refer to the number of warp and weft threads per inch. For example, 20-count Lugana means there are 20 warp and 20 weft threads per inch of fabric. In 18-count Davosa, there are 18 warp and 20 weft threads per inch.

20-count Lugana has 20 warp and 20 weft threads per inch.

18-count Davosa has 18 warp and 18 weft threads per inch.

Thread count is vital to knowing how much area your motif or overall pattern is going to cover. A stitch pattern that is worked over 120 threads will cover 6″ in 20-count fabric. That same stitch pattern will cover a little over 6½″ on 18-count fabric. When framing a pattern, combining motifs into a larger grouping, or substituting one pattern for another, it is important to know this in advance to ensure your motif or overall pattern will fit your finished project.

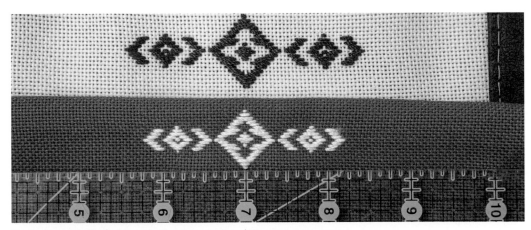

Kogin motif Full Pattern 9 worked on 20-count and 18-count evenweave.

Knowing the threads per inch of your evenweave will also help you select either floss or thread and, further, how many strands of each. If the fabric has fewer threads per inch, the fabric threads will be further apart, meaning your stitching thread should be fuller to fill in the gaps. Two strands of Aurifil 12-weight or 3 strands of Aurifil Cotton Floss will not fill the gaps of an 18-count fabric and the resulting pattern will look sparse and disjointed. Instead, 3 strands of 12-weight and 6 strands of embroidery floss would work much better to ensure the gaps in the 18-count fabric are fully filled and that the rows of the kogin pattern lay snuggly against one another, giving the finished motif or overall pattern a much fuller look. For all of the stitch patterns in this book, we are using either 3 strands of 12-weight thread or 6 strands of floss.

▋ MONO–THREAD WEAVE VS. MULTI–THREAD WEAVE

If you look closely at evenweave fabrics, you will see that some of the fabric threads are made up of closely plied strands (mono-thread weave) and some appear to be made up of strands that lay next to one another (multi-thread weave). Mono-thread weave is a single thread woven alternately over and under other single threads. Multi-thread weave fabric appears to have multiple threads laid next to one another and woven alternately over and under other threads of the same multiple.

Mono-thread weave fabric

Multi-thread weave fabric

Most fabrics we encounter daily are mono-thread. Multi-weave threads are typically used for cross-stitch and embroidery where one needs to split threads in order to create half and quarter stitches. Aida cloth is the prime example of a multi-thread weave and is primarily used for cross-stitch. We do use a higher-count Aida cloth for some of our kogin because there are more threads per inch, and we are using thread or floss that sufficiently fills in the gaps. When choosing which type of fabric for projects, the consideration is how "wide" the individual fabric threads are in relation to your stitching thread. The wider the threads, the further apart your rows of stitching will lay, which means the base fabric will show through the stitches and your finished pattern will not look as full. Because of this, Aida cloth is not standard for us in kogin unless it is of a high thread count.

18–count Aida

Texture and Content

The texture and content of the base fabric can greatly affect the finished look of your projects, as well as the ease with which you work. A polished cotton-thread fabric or fabric woven from high-twist plied thread will be smooth and is less likely to snag your stitching threads as you pull them through. The threads of smoother fabrics are easier to manipulate because they don't split as easily when you work your needle around them. Conversely, more loosely spun fabric threads can split more easily—even when using a kogin needle—possibly causing your stitches to not line up properly with the adjacent rows.

A smooth fabric like the 20-count Lugana in the *Peacock Jacket* (page 164) will give your stitch pattern a flat, even look. The fabric threads are smooth and of consistent width, so the stitching threads lay nicely next to one another, giving the overall stitch pattern an even look.

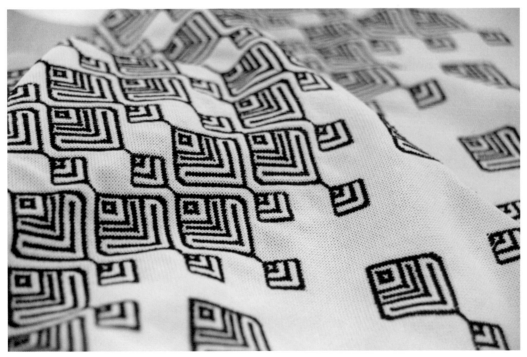

Peacock Jacket back

A more rustic fabric like the Cork Linen we used for the *Sashiko Vest #2* (page 155) will add a bit of a character to your finished work due to the slightly uneven widths of the thick and thin woven threads. It may still have the same number of warp and weft threads per inch, but the subtle variation in widths of the threads means your rows of stitching and even the individual stitches will, sometimes, not lay as closely together. The overall effect

of the kogin pattern is not diminished at all by this but, instead, adds visual texture to the finished piece.

Softer fabric like the Cork Linen can be a little more difficult to hand tension and maneuver, and there is the possibility that a regular sashiko needle can puncture and split the fabric threads. This is where the special kogin-zashi sashiko needle (page 15) with a more blunted tip makes working with these softer fabrics much easier, allowing the tip of the needle to move the fabric thread aside rather than piercing it. Even so, attention must be paid because even these specialized needles can split the threads of the softer fabrics.

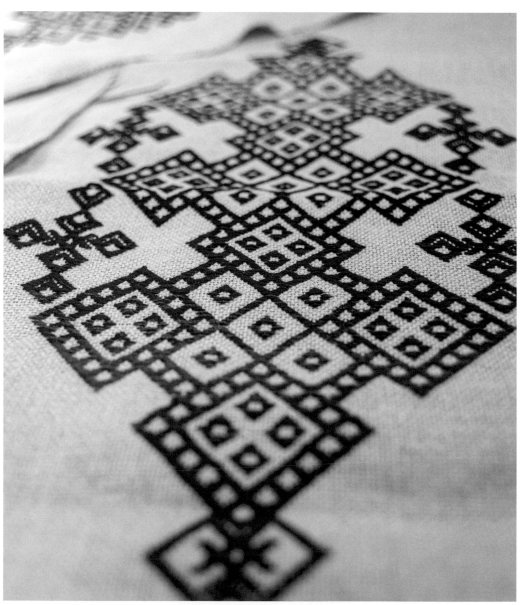

Sashiko Vest #2 (page 155)

◼ Have Fun and Experiment!

When choosing fabric for kogin stitching, the only *real* requirement is that you can see the individual base fabric threads and that your working thread is not so large that it distorts the base fabric. We have played with plastic canvas, screen, outdoor mesh fabrics, and even chain link and hog wire fencing. If you can count over and under threads or "threads," and you can weave thread, rope, yarn, or plastic tubing through it, why not embrace the creative chaos and give it a try?

- -

NON-EVENWEAVE FABRIC

Fabric that is non-evenweave can be used for kogin-zashi. Rustic linens, woven wool, even burlap that is not strictly woven on a 1:1 make for beautiful kogin panels. It is important to realize, however, that traditional kogin patterns and motifs are based on a 1:1 ratio, so they will not look the same on a fabric that is not evenweave. More threads per inch in one direction or the other will distort the finished pattern accordingly ... THIS IS NOT A BAD THING ... just something to keep in mind.

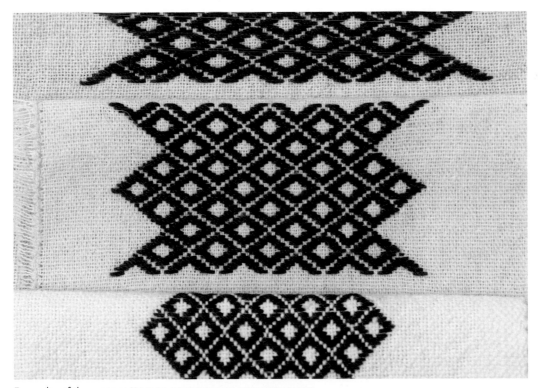

Examples of the same pattern on evenweave vs. non-evenweave

- -

BEFORE YOU
Stitch

First Steps!

You are probably eager to push forward and put needle and thread to fabric. But first, we offer these instructions to make your stitching more enjoyable.

▋SEPARATING AND PLYING EMBROIDERY FLOSS

At first glance, Aurifil Cotton Floss is a neat little bundle of embroidery threads put together in a braid. And that's true. It is. While the strands can be used exactly as-is off the spool, floss comes to life when it is separated strand by strand from the braid and then held together. First separating then holding the floss strands together puts air into the resulting bundle of thread, making your stitches fuller and more likely to fill in the gaps of the evenweave. Here is our method for separating these strands.

1. Cut your desired length of thread and, separating one strand out from the rest of the braid, firmly grasp the single strand with the fingers of one hand while holding the rest of the braid in the fingers of the other hand. *fig. A*

A.

2. Gently pull the single strand from the braid by sliding the remaining braid strands down the length of the single strand. Don't stress out if the braid strands start to bunch up. That is easy to work out or it will just fall out once the single strand is free. *fig. B*

B.

3. Continue working the braid down the length of the single strand of floss until the strand falls free and the braid relaxes. *fig. C*

C.

4. Repeat for each strand until all 6 strands are separated. Be sure to lay each strand separately to prevent tangling. *fig. D*

Pick up all the strands of floss and smooth over them with one hand, being careful to not flatten or retwist the floss.

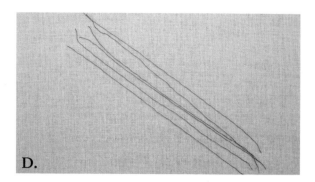

Note: Color Blending

This is the step where you will replace different colors of thread to your floss bundle for color blending. Add new colors of floss one strand at a time for subtle color blending effects or two at a time for a faster change. We find that replacing two strands of a different color of floss creates a smooth blending effect.

Two strands of a lighter shade of floss added to 4 strands of a slightly darker floss

▌THREADING THE NEEDLE

Unlike moyouzashi and hitomezashi, kogin stitching does not use a doubled single strand of thread. Kogin stitches are made with either multiple strands of thread held together (as with our 12-weight thread held together in 2- or 3-strand groups) or multiple strands of floss held together. Therefore, threading the needle is like standard sewing, apart from there being more than a single strand of thread to put through the eye of the needle.

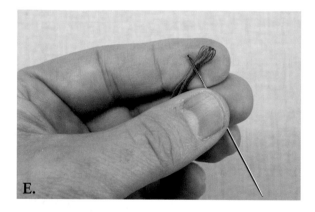

1. Holding the desired number of threads together, insert them into the eye of the needle. *fig. E*

2. Pull the excess thread through the eye of the needle so it overlaps the working section of the thread to keep it from slipping out of the needle as you are making stitches. Just be sure to adjust this tail so you don't stitch it into the pattern. Why do we tell you these things? Yeah *fig. F*

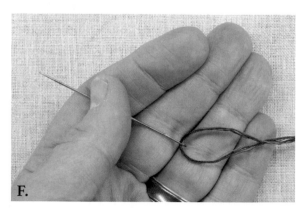

▌ CUTTING YOUR FABRIC

One of the unique qualities of evenweave fabric we use for kogin-zashi is the ability to square it up without using engineering tools and a T-square. Mark the desired dimensions on the outside of the fabric and use the thread pull method to create a perfectly straight edge and square corner.

Thread Pull

1. To start a thread pull, mark the dimensions of your fabric. *fig. G*

2. Now find a single loose thread near one of the marks at the edge of the fabric. *fig. H*

3. Using a tailor's awl or a pair of pointy tweezers, work the thread loose until you have enough to hold onto firmly. *fig. I*

4. Once you have a firm grasp on the thread, begin pulling the thread out of the fabric by gently moving the fabric away from the end of the thread. This will cause the fabric to bunch up along the length of the thread. *fig. J*

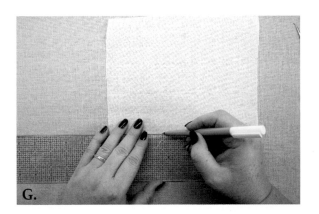

G.

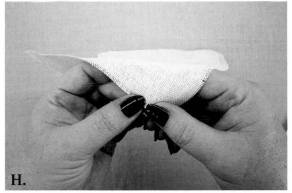

H.

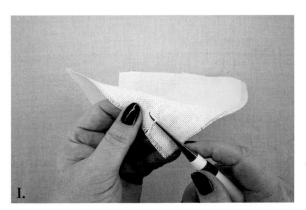

I.

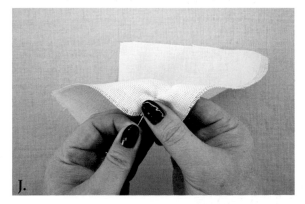

J.

5. Smooth the bunched fabric over the remaining length of the thread, moving the fabric away from the end you are holding. *fig. K*

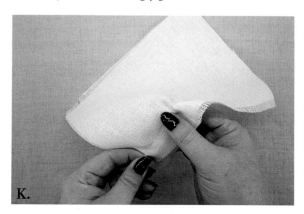

K.

6. Repeat this process, trimming away the excess "pulled" thread as you go. *fig. L*

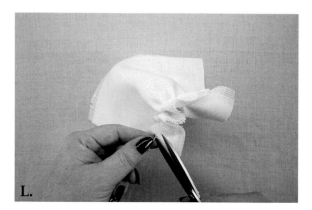

L.

> ### Note: Keep Calm and Carry On
> *Don't panic if your pulled thread breaks. Use a thread pick or awl to unweave the thread enough to hold firmly and start bunching and pulling again.*

7. With each pull and snip, you will be left with a gap in the fabric. Continue this process until you have a gap that is the length of your cut fabric measurement. *fig. M*

M.

8. Repeat the process with a thread that will intersect the end of your pulled thread gap until the two gaps meet. *fig. N*

N.

9. Now, use scissors to cut along both gaps. *fig. O*

10. And there you have it! Fabric with a perfectly straight and squared edge. *fig. P*

O.

P.

▍DON'T BE A-FRAY-ED

As you work with evenweave fabric, the outside edges tend to fray and you can easily lose your entire seam allowance over the course of handling a piece of fabric during a project. To prevent this, use hand or machine stitches to secure these outside threads.

There are three ways to finish the edges of the cut fabric before you stitch:

Hand Overcast

The overcast stitch is basically a whipstitch of loops worked along the edges of your fabric. Be sure to catch a few of the outside threads and do not pull your stitches so tightly that they pull the threads of the ground fabric. See the overcast stitch tutorial in Special Techniques (page 63).

Machine Overcast

If you have access to a sewing machine, you can use a zigzag, overcast, or overlock stitch to secure the edges of your fabric. Be sure to test the width, length, and tension of your stitches to ensure a secure edging that will not pull and mangle your fabric. We always test on a small piece of fabric the first time we machine stitch it.

We love hand stitching but our BERNINA B790 PLUS makes quick work of securing the edges of our evenweave fabric; we arrive at the stitching part of our project faster!

Photo courtesy of BERNINA of America

Fabric edge secured with machine overcast stitch

Overlock Machine

Just like your sewing machine, an overlocker or serger will do a quick and clean edging for your fabric. As a bonus, you can define the edges of your fabric with your thread pull, then use the blade on your overlocker or serger to cut while it secures the edges.

Our BERNINA L 460 overlocker machine makes quick work of securing the edges of our evenweave fabric.

Photo courtesy of BERNINA of America

▌ TO WASH OR NOT TO WASH?

Prewashing project fabrics removes things like stiffeners, starches, preservatives, and insecticides. Generally, the rule with pre-washing fabrics is that you should wash the fabric (or not) according to how you will wash the finished piece. Whether machine washing and drying, machine washing and laying flat to dry, or hand washing, prepare your fabric in whatever manner the finished project will be treated.

Pro Tip: Not So Fast There

Overcast all edges before you wash or you will lose a lot of your evenweave fabric.

Now that you have your tools and your fabric prepped, let's put needle and thread to fabric and make your first kogin-zashi stitches!

▌ FIND YOUR CENTER

To ensure your stitches are properly placed on your fabric, find the center of your fabric. All the large stitch pattern charts in this book are marked with both a vertical and horizontal center line as well as a red dot to indicate the exact center of the pattern in the context of the cut fabric. Individual motifs are marked with a single red dot at their center. Depending on where you want your pattern or individual motifs to be placed on your project, you should use a thread to mark those same lines or dots on your fabric.

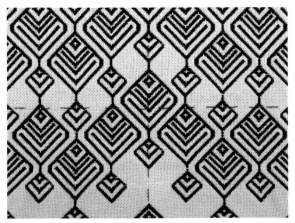

Two lines of contrasting thread made with large stitches on a piece of fabric clearly indicate the vertical and horizontal centers.

1. The easiest way to find the exact center of your fabric is to first fold the fabric in half lengthwise and make a light crease with your fingers near the center section. *fig. Q*

2. Then, fold the fabric in half crosswise and look for a single thread that is at the intersection of both folds. *fig. R*

3. Loosely attach a thread to this spot and there you have it: the center of your fabric. *fig. S*

> ### Pro Tip: Centering
> Starting at the center stitch of your design and working out to either side is the easiest way to ensure your design is centered on your fabric.

▌WHERE TO BEGIN

For smaller motifs and designs, you can simply count the lines from the center of the stitch chart to the beginning of that row then count the same number of threads from the center of your fabric and begin stitching there. For larger designs and more complicated motifs, it might help to start at the center:

1. After you cut your first length of thread, stitch the center stitch of your design with the halfway point of your length of thread and work to the end of that row. Continue stitching the first half of the motif until you run out of thread and weave in your thread tail. *fig. T*

2. Now go back to that center stitch and rethread your needle with the other half of your first length of thread and work in the opposite direction until you run out of thread and weave in your thread tail. *fig. U*

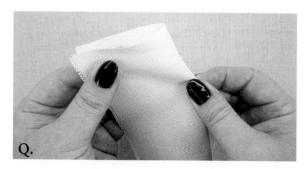

Q.

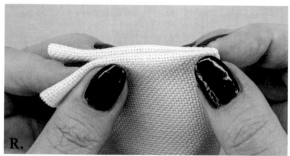

R.

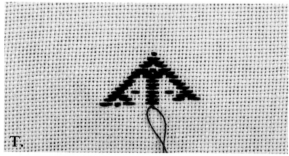

S.

T.

U.

BALANCED DESIGN

Kogin-zashi patterns are as much about the negative space between the stitches as they are about the actual stitches. To best appreciate large pieces of kogin, it should be noticed that the stitches are creating both negative and positive designs. Look for patterns that show up as negative space between the threaded areas in addition to the more readily seen positive areas filled by thread. This negative space can be enhanced even further by using a matching or contrasting color background fabric.

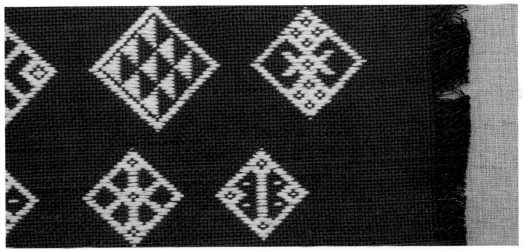

Note how the background fabric, the negative space between the stitches, is just as much a part of the overall design as the stitches themselves.

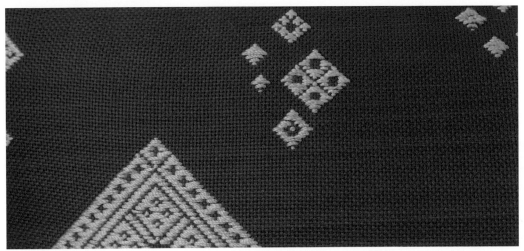

The use of red evenweave fabric in the Lookin' At Pillow (page 147) plays a big part in the overall pattern by enhancing the stitches made in complementary shades.

READING KOGIN-ZASHI
Stitch Patterns

Kogin stitch patterns are a visual representation of the stitches as they lay on the surface of the fabric. Stitch what you see!

How to Read Kogin Patterns

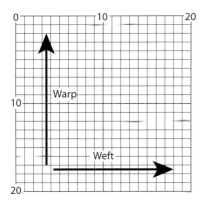

The grid lines are the even-weave vertical and horizontal threads. Every 10th grid line is thicker to make counting larger charts easier.

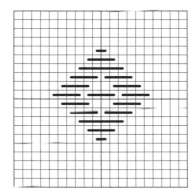

The heavy, colored lines are the kogin stitching threads as they appear on the surface of the fabric.

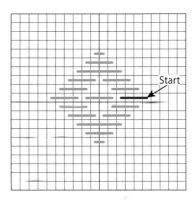

1. To read the chart, find where a stitch starts ...

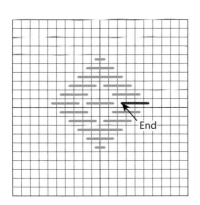

2. ... then find where it ends.

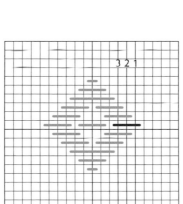

3. Now count the number of background lines the colored line crosses. In this case, the stitch line crosses 3 background lines. This means our kogin needle will come out of the fabric and cross over 3 threads on the surface of the base fabric before we insert it back into the fabric.

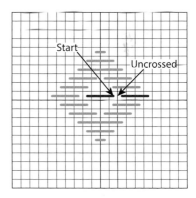

4. Moving along the chart, find the point where the next stitch begins.

5. Now count the number of background lines between the end of the last stitch and the start of the next stitch. The number of background lines you just counted is the number of evenweave threads your kogin needle will pass under before you push it back up to the surface of the fabric.

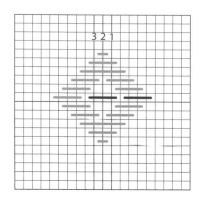

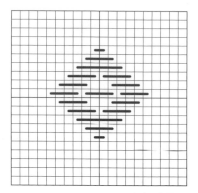

6. Repeat this process across the row. When you see a colored line crossing 3 background lines, you will pass your needle over 3 threads of the evenweave. If you see a space where no colored lines cross, count the number of uncrossed background lines and pass your needle under that many evenweave fabric threads.

7. Continue to read the chart and stitch row-by-row in this manner until you have completed the pattern.

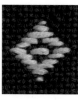

Pro Tip: Look Out Below

Yes, kogin is counted thread work but, rather than counting every single thread of every single row, make the current row of stitches by looking at the previous row.

Yes, kogin is counted thread work but, rather than counting every single thread of every single row, make the current row of stitches by looking at the previous row. It is easier to look where to place your stitches relative to the previous row rather than count every single stitch of every single row.

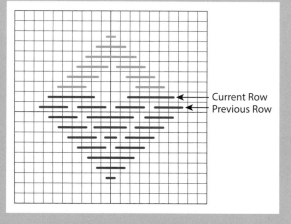

One way we aid in doing this is to place a marker across our stitch chart that allows us to see only the row we are working and the tops or bottoms of the stitches in the row we just worked. This is especially easy if you are viewing your charts on a digital device. You can enlarge the chart and line up your working row and the previously worked rows with the top or bottom of the screen.

Note: Hey Lefties!

Reading kogin stitch charts is the same for left-handed stitchers as it is for right-handed. You can work the chart from either the left or the right; the end result is the same. If you get confused, just stitch so your pattern matches the chart.

▌PERFECT PLACEMENT

The center point as indicated in the stitch charts appears in one of two places: the center point of the stitch pattern or the center point of the cut fabric. All the large pattern charts in this book are marked with both a vertical and horizontal center line and a red dot to indicate the exact center of the pattern in the context of the cut fabric. Individual motifs are marked with a single red dot at their center. Depending on where you want your pattern or individual motifs to be placed on your project, use a thread to mark those same lines or dots on the base fabric.

On larger panels, or panels like the sleeves or back panels of the jacket, the stitch pattern is not designed to be centered on the cut fabric. Because of this, the red centering lines and dot on the stitch chart indicate the center point of the cut fabric to ensure proper placement of the overall stitch pattern on the cut fabric.

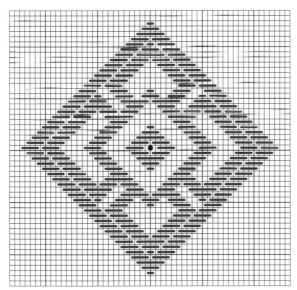

Red dot indicates center of motif.

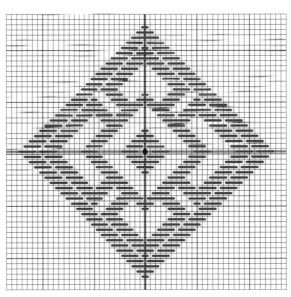

Red dot and lines indicate center of cut fabric.

▌BREAKING IT DOWN

For large kogin patterns, we have included "zoomed in" sections of the stitch chart. These enlarged chart sections are meant to be worked as repeats either across the work or on the edges. Please reference the larger chart and these more focused, enlarged chart sections together to make your stitching experience easier.

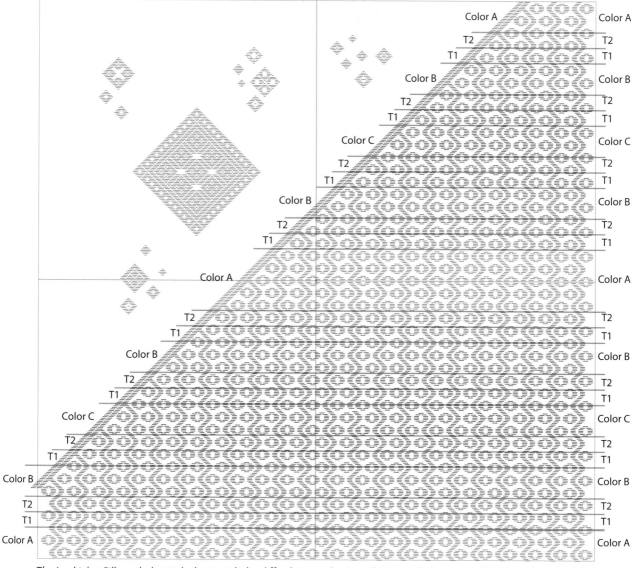

The Lookin' at Pillow whole stitch chart might be difficult to read or just plain overwhelming. See this chart shown in full-page quadrants and the repeat charts in the Kogin-zashi Stitch Library (page 72).

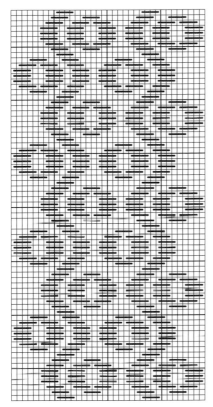

Lookin' at Pillow, Repeats Chart 1. This is the right edge repeat section. You will work this when you are on the right-hand side of the pattern.

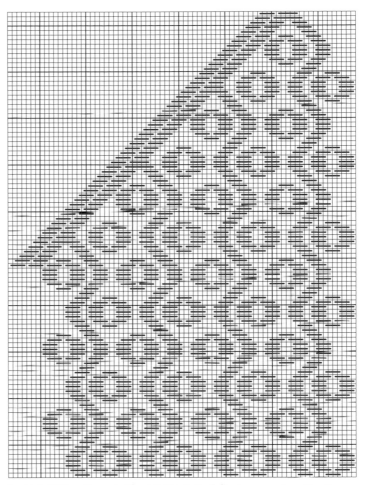

Lookin' at Pillow, Repeats Chart 3. This is the left edge repeat section. You will work the stitches in Repeats Chart 1 until you reach the edge of the pattern. Then, you will work this edge stitch.

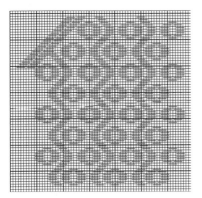

Lookin' at Pillow, Repeats Chart 2. To make larger stitch charts easier to read, we break them down into smaller repeat sections. This is the chart for the main repeats in the Lookin' at Pillow overall stitch chart. After working either Chart 1 or Chart 2 (depending on which end of the row you are working from), this section is repeated across the main part of the base fabric.

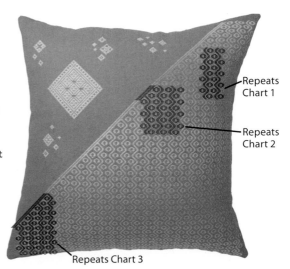

Repeats Chart 1

Repeats Chart 2

Repeats Chart 3

If you are working this pattern from right to left, you would first work the stitches from Chart 1, then work the main repeats in Chart 2 until you reach the left side of the pattern, where you will work Chart 3.

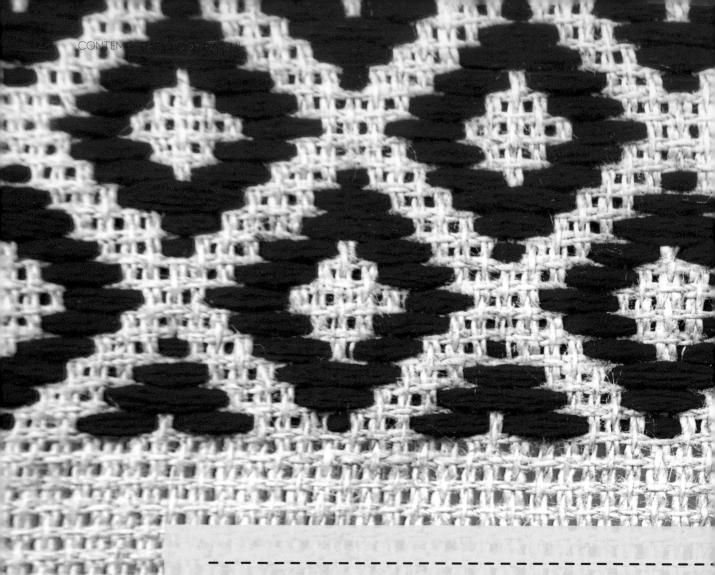

FLOATS

A float is a thread carried along the back of your fabric between parts of a single motif or separate sections of a large pattern. Our general rule of thumb is if the float is longer than 10–12 threads, we turn and finish the overall section on one side of the 10–12 thread gap, coming back later to finish the skipped area. If the gap narrows later in the pattern, we then pick up the full pattern again, working the complete row.

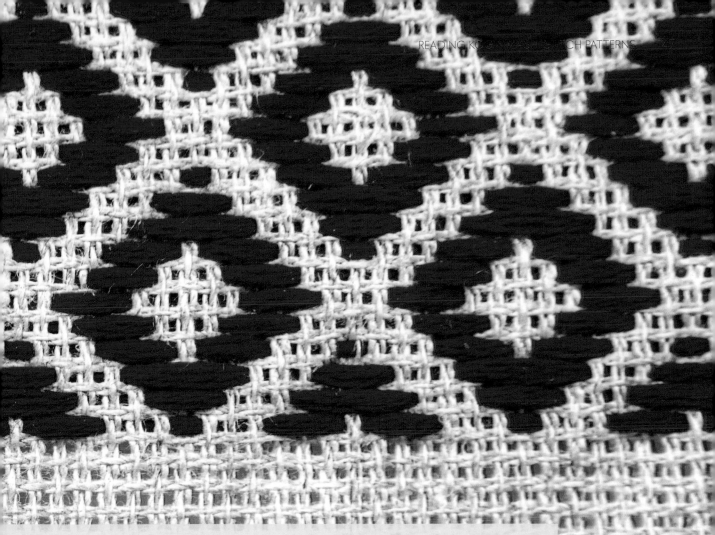

Sometimes, as in the case of the back of the Peacock Jacket pattern (page 164), we worked the main part of the larger pattern, coming back later to individually fill in the points at the top of the pattern and smaller floating motifs along the bottom. The same is true for the Lookin' at Pillow (page 147). The main stitch pattern is worked first, then the smaller motif clusters and sparkles are added after. In such cases, it is vital to follow the guidelines we provide for counting threads between the motifs carefully and placing a piece of marker thread where the center of those individual motifs is worked.

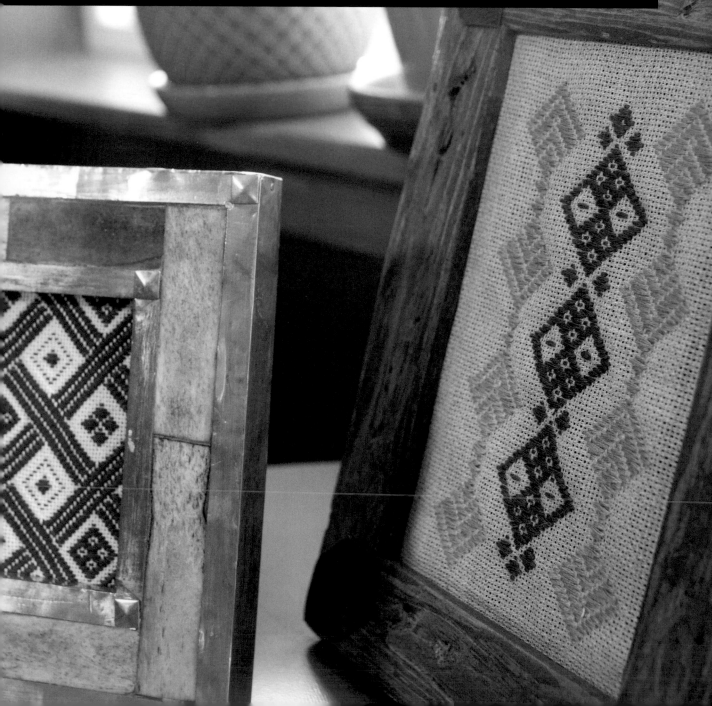

UNSHIN:
Handling the Needle

Kogin-zashi (and sashiko as a whole) is not *just* the stitch patterns seen in books or created on fabrics. "Kogin" and "sashiko" describe a type of stitch, a technique, the way those stitches are made, the tools that are used to make them, and the application of those stitches. Those words do not represent one *thing* but describe a way and a mindset... if you want to go deep. The way the stitches are created is called *Unshin*.

Unshin is the Japanese word that describes handling the needle. This is not exclusive to kogin or sashiko in general but applies, more widely, to all hand needlework. Specifically, unshin is the way the needle is manipulated for particular stitches but, generally, describes how the needle is handled for different techniques.

Like other sashiko forms, kogin-zashi is worked using a sashiko-style running stitch and the base fabric is hand tensioned. As the running stitch is worked, the stitcher loads fabric onto the needle which is moving through the fabric by pushing down and lifting up threads with the needle. When the needle is full, it is then pushed through the fabric using the palm thimble. Finally, the fabric is redistributed over the thread and the section just worked is evened out so the thread and fabric lay even and flat.

Terminology

NEEDLE HAND AND FABRIC HAND

When we teach, we will refer to your needle hand and your fabric hand. Whether you are left or right-hand dominant, your needle hand is the hand you use to hold your needle, and your fabric hand is the opposite hand. The fabric hand feeds the fabric toward the point of the needle as you make your sashiko stitches.

Needle Hand

The needle hand both holds the needle and maneuvers it along the path of the stitching line and pulls the fabric you have made stitches in onto the needle as the needle moves through the fabric. The middle finger and thumb of the needle hand perform the up-and-down rocking motion of the needle as it moves over and under the threads of the fabric, pushing threads down and lifting threads up to make the individual stitches of the kogin pattern. Along with the fabric hand, the needle hand maintains the tension of the fabric to make the movement of the needle through the fabric easier. In addition, the palm thimble is on the middle finger of your needle hand. The palm thimble braces the needle against the divots in the metal and gently pushes the needle forward as you pick up and push down the base fabric threads.

Fabric Hand

The fabric hand holds the side of the fabric that you have not stitched into yet and feeds that fabric toward the tip of the needle as the stitches are made. The fabric hand also "wobbles" the unworked fabric up and down over the tip of the needle. Along with the needle hand, the fabric hand maintains the tension of the fabric to make the movement of the needle through the fabric easier.

Kogin-zashi Unshin Exercise

Kogin-zashi practice swatch

For this exercise, we are going to both practice your unshin—how you handle the needle—and create your first stitch pattern. Like any new skill, it will take a little practice to develop a rhythm with your needle and fabric to achieve smoother running stitches. This practice pattern is both a great filler stitch and makes a good border for projects.

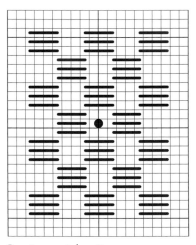

Practice swatch pattern

Note: Push and Lift

If you have practiced other forms of sashiko, you will immediately notice that the unshin of kogin-zashi is different in that you are pushing down and lifting up the evenweave threads. Rather than actually puncturing the base fabric, you are pushing the needle into and lifting it out of the holes created by the open weave of the fabric.

▌FIRST STEPS

1. Thread the needle. *fig. A*

2. Place the palm thimble on your middle finger. *fig. B*

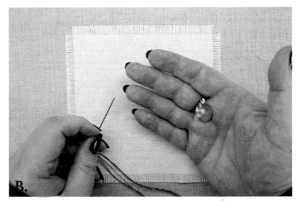

3. Starting about 1½″ from the edge of your practice fabric and, coming from the back of the fabric, bring your needle up through the space created by the overlapping of the warp and weft threads. *fig. C*

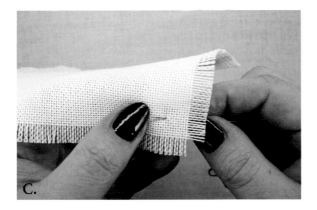

4. Brace the end of the sashiko needle with the eye against the palm thimble, using the little dimples in the metal to keep the needle from slipping around. *fig. D*

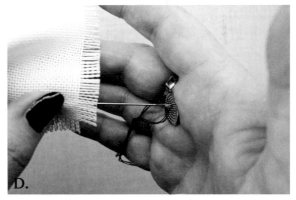

5. Place your middle finger under the needle beneath the fabric. *fig. E*

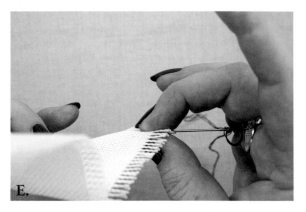

6. Place your thumb on the top of the needle over the fabric. *fig. F*

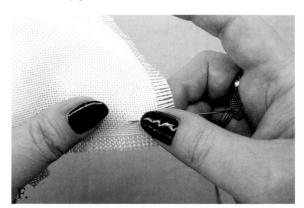

You now have the needle braced in three places: *fig. G*

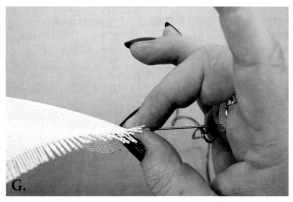

Eye of sashiko needle braced against dimples of palm thimble while shaft of needle is held between middle finger and thumb.

7. Gather the fabric with your opposite (fabric) hand. *fig. H*

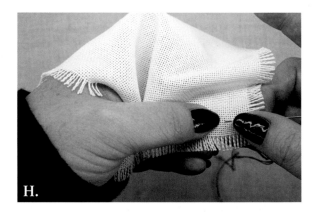

Remember, you will keep the tension on the fabric between your hands to make the needle move more easily over and under the threads of the fabric. This tension with your hands takes the place of an embroidery hoop or a stretcher frame. As you pull the fabric onto your needle with one hand, you will slowly release the fabric from your opposite hand and feed that fabric toward the needle. One hand feeds the fabric while the other pulls the fabric onto the needle. Don't worry ... the execution of this becomes automatic as you start making stitches. Soon you won't be thinking about it at all.

▌ STITCH ON!

Now you will begin moving the needle through the base fabric over and under the vertical threads. To accomplish this, you will coordinate the movements of; gently wobbling the fabric up and down to meet the tip of the needle, bracing the needle against your palm thimble, and pulling the stitched fabric onto the needle the number of threads indicated in your pattern.

1. With your fabric hand, push the fabric up to meet the tip of the needle while pushing the shaft of the needle down to push the threads down. Advance the needle by the indicated number of threads according to the pattern—in this case, three threads. *fig. I*

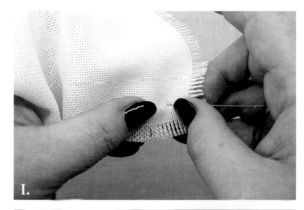

I.

2. While pulling the worked fabric onto the needle with your middle finger and thumb, advance the needle the indicated number of threads (3 threads) and use your fabric hand to push the fabric down to meet the tip of the needle (this is a subtle movement) while lifting the needle shaft to lift the three threads just worked under and pushing the needle tip to the fabric surface. *fig. J*

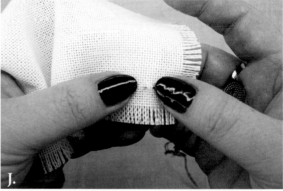

J.

3. Repeat these two stitches, advancing the needle across the fabric and loading more fabric onto your needle. *fig. K*

Take your time and be patient with yourself while you learn the rhythm and feel of moving the needle and fabric together. You are performing three coordinated movements: advance and brace the needle, pull and feed the fabric, wobble the fabric up and down to meet and cover the tip of the advancing needle while scooping threads up with the tip and shaft of the needle. This overall handling of the needle to make running stitches is Unshin and must be repeated in order for this combination of movements to solidify as a single natural movement.

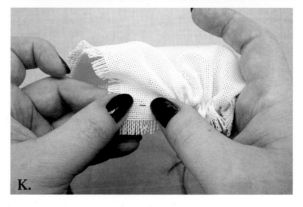

K.

4. When you come to the end of your row (or the end of your fabric), finish your line of stitches with your needle point under the fabric. Remember to leave the indicated amount of unworked fabric on the edges of your work. Some patterns give you a specific seam allowance. Here, we are leaving 1½″ on the edge of our swatch.

You will have a handful of fabric in your needle hand. This fabric is bunched up on the needle like the gathers of a curtain when they are pulled open. This is where the true power of your palm thimble comes into play. *fig. L*

Pinch, Push, Pull

1. Brace your needle against the palm thimble and pinch the gathered fabric nearest the needle tip in place with the thumb and middle finger of your fabric hand so it doesn't move with the needle. Make sure your grip is firm enough to hold the fabric in place but loose enough to allow the needle to slide through your fingers. With the palm thimble, push the needle as far as possible through the gathered fabric. *fig. M*

2. While holding the fabric around the needle tip with your fabric hand, use your needle hand to pull the fabric across the length of the thread. *fig. N*

3. With your needle hand, firmly hold the fabric at the beginning of your row and pull the remaining thread through the fabric. Be careful to not pull your starting tail all the way through your row. Why do we tell you these things that seem obvious? Because we don't want you to suffer the same DANG IT moment we have in the past. *fig. O*

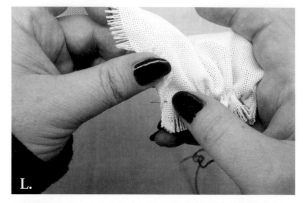

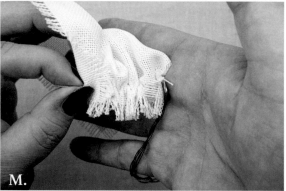

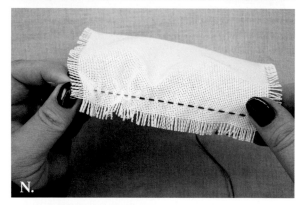

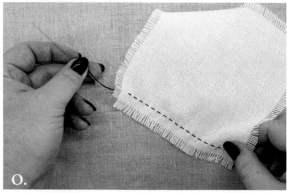

4. With your needle hand, pinch the fabric and thread at the beginning of the row and gently run your fabric hand along the length of the thread to redistribute the fabric evenly over the thread. *fig. P*

5. Grasping the fabric at the beginning and end of your row, give the fabric a gentle pull in opposite directions to help realign the threads of the base fabric in preparation for your next row. *fig. Q*

And there you go ... TAADAA!! You have made your first-ever row of kogin-zashi stitches. Do a little happy dance then get back to it ... here comes the second row!

SECOND ROW

1. With the top side of your fabric facing you, rotate your work 180° so your needle is again on the needle hand side. *fig. R*

2. Coming from the back of the fabric, bring your needle up through the space one thread in from where your last stitch ended. *fig. S*

> ### Note: Chart vs. Fabric
> *When you are stitching every other row, notice that the pattern stitch you are working is backward and upside down on the fabric relative to the chart. This can be confusing for fledgling kogin-zashi stitchers and takes some time to get used to. It is especially important to keep in mind if you are working on a stitch pattern that is not a mirror image of itself across the center line.*

For row 2, and all subsequent rows, repeat these steps layering rows of thread next to each other. At the end of your row, do the Pinch, Push, Pull and pull the thread through the fabric until ...

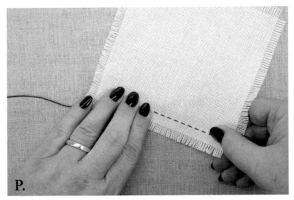

P.

Q.

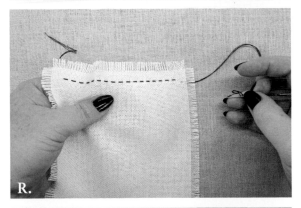

R.

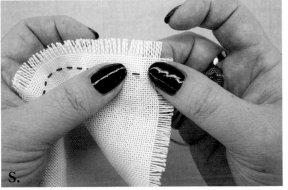

S.

3. ... until a small loop of thread remains on the back of the fabric. This safety loop is essential to maintain proper tension between the thread and fabric. Leave a larger loop when you first start. You can adjust the size of the safety loop when you come to the end of your row and smooth the fabric over the length of the thread. Failure to leave a safety loop will result in an extremely tight pucker that will pull the threads of the base fabric out of alignment leaving a hole in your work. In the case of garments and larger projects,

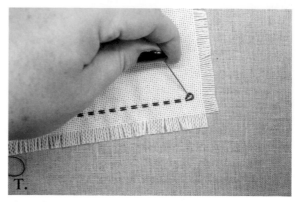

Always leave a safety loop between rows.

this pucker and resulting hole can worsen with wear and use. Always leave a safety loop! *fig. T*

Second row finished! WOOHOO!! Repeat these steps for all rows. With each row, remind yourself of the Stitchers Promise (page 7). For most stitchers, this is a new technique. The more rows you make, the more consistent your stitches will become and the more relaxed you will feel when you make your stitches.

Pro Tip: Wiggle Room

As we redistribute our fabric across a row of stitches, we like to give the fabric a wiggle or two; first in line with the horizontal threads and then with the vertical threads of the base fabric. As the thread or floss passes through the holes in the even-weave fabric, it can skew the fabric threads and cause the stitches to lay uneven. This can make the overall pattern appear uneven, but can also make subsequent rows more difficult to see due to wonky threads covering the holes. Giving the fabric a little wiggle realigns the fabric threads and allows the stitches to lay flatter and more even.

▎ THE DISAPPEARING ONE-OVER STITCH

Making a one-over stitch using a kogin running stitch can be tricky. More often than not, the stitch disappears into the fabric by slipping beneath the loosely woven fabric threads. This is especially true of softer fabrics and of those with higher thread counts. If we discover this is happening with our one-over stitches, we use this trick. While this is not a traditional kogin stitching technique, it does make our patterns that include these single stitches more clear and precise looking.

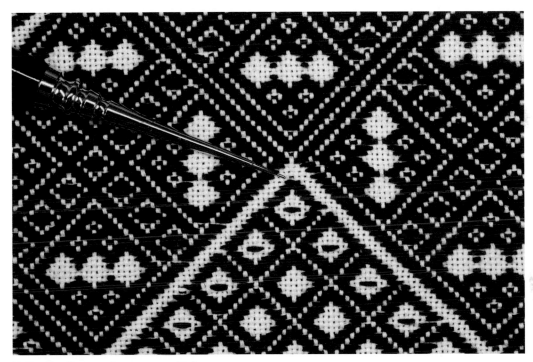

Notice the disappearing one-over stitch

1. Bring your needle up from the back of the fabric on the opposite side of the stitch you want to work over. *fig. U*

2. Pull the needle all the way up through the fabric, leaving a small loop on the back of the fabric. *fig. V*

3. Moving backward against your direction of stitching, insert the needle from front to back. *fig. W*

4. Gently pull the thread through until the one-over stitch is snug but not tight against the surface of the fabric. *fig. X*

5. Continue stitching your row as usual.

▌ SEW ONE-OVER

Another "disappearing one-over stitch" situation can occur on a higher thread count fabric or a fabric that grabs the stitching thread, a bit like the 20-count Lugana we used for the Tote Bag (page 143). In such cases, the fabric is densely woven, and the threads are very even in width. When we make a line of stitches and pull the thread through, a one-over stitch in that line of stitches could be pulled so tightly that it does not stand out enough against the surface of the fabric.

1. To prevent a disappearing one-over on a fabric with a tighter weave, pull the thread all the way through and tension the fabric properly across the stitches already made. *fig. Y*

V.

W.

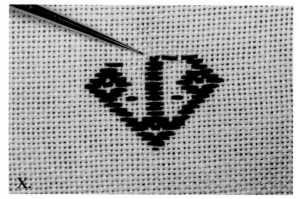
X.

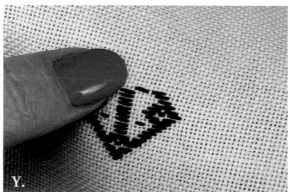
Y.

2. Insert the needle into the first space for your one-over straight up and pull through. *fig. Z*

3. Insert the needle into the following space for your one-over straight down (think stab). *fig. AA*

4. ... and gently pull through to the back of the fabric until the single stitch is standing nicely against the surface of the fabric. *fig. BB*

Continue along the line of stitching until you reach the end of the row. When you pull the remaining thread through the fabric at the end of the row, be careful to not pop that one-over stitch down into the fabric again. We usually pinch the thread next to the stitch while pulling the thread through, then redistribute the fabric over the remaining stitches in the direction of the end of the row away from the one-over stitch.

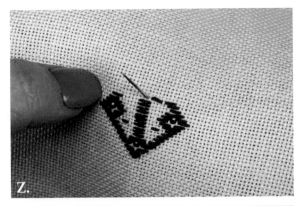

Z.

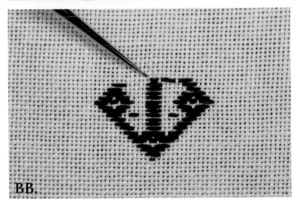

AA.

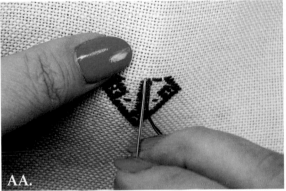

BB.

SPECIAL
Techniques

These hand-sewing and finishing techniques will help you make the projects.

Note: Needle Hand / Fabric Hand

For the purposes of these tutorials, "needle hand" is the hand you hold your needle in and "fabric hand" is the opposite hand.

WEAVING IN TAILS

Finishing your projects beautifully is just as important as being able to create perfect stitches. Weaving in the tails of your stitching threads ensures they will not work loose and that they don't snag and snarl up while you are stitching the rest of your project. Do we always weave in our tails as we go every single time on every single project? No. Well ... to be fair, Jason does. Shannon, not so much. But, still no. Should we? Absolutely. In good faith, here is how to weave in your tails as you go or at the end.

> ### Pro Tip: Thoughts On Weaving in
>
> *Note: We do, as a general rule, try to finish a thread at the end of a full row.*
>
> Another tip (again so soon?): Shannon is self-described as a "paranoid crafter" and will not weave in tails until they are *beyond* certain that the rows that thread is attached to are proven correct. She finds it easier to fix mistakes if she weaves in her thread tails every 2 thread changes.

Weaving In

1. Turn your work over to the back and thread the tail through the needle. If you are at the end of a row, you can leave the thread on the needle. *fig. A*

2. On the backside of your work, thread your needle with the tail to weave in. Go back one row and insert your needle under at least 2 sections of exposed evenweave threads, being mindful to not split the thread on the surface of the fabric. Essentially you duplicate the visible stitch on the front. *fig. B*

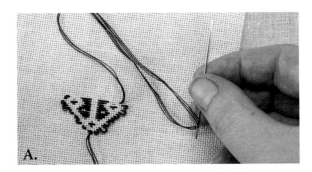
A.

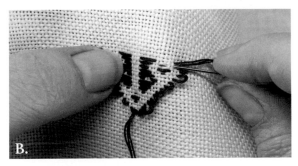
B.

3. Check the front of your work. The needle might be visible under a stitch, but the pattern will remain the same.

4. Pull your thread through. Be very careful to snug the thread without pulling the last stitch of the last row you worked. We leave a small loop just like we would at the end of a row. *fig. C*

5. When you are confident your thread tail is secure, trim off the remaining thread, leaving a scant ¼″ and STITCH ON! *fig. D*

▌LADDER STITCH

We use the ladder stitch for closing the last bits of a machine-sewn seam like those in the Lookin' at Pillow (page 147), Placemats (page 134), and Coasters (page 131). This stitch goes by ladder stitch or slip stitch, depending on who taught it to you. *fig. E*

1. Bring the needle up from inside the seam allowance fold. This hides the knot inside the fold.

2. Sewing only through the folded fabric of the seam allowance, make a small stitch on the opposite side of the seam. Your needle should go into the fabric adjacent to where it just came out, behind the fold to hide the thread. The stitch should be no longer than ¼″ or your finished seam will pucker.

3. Make a small stitch on the opposite side of the seam. Again, your needle should go into the fabric directly across from where it just came out, traveling behind the fold no further than ¼″.

4. Repeat steps 2 and 3, pulling on your thread to close up the seam every few stitches. When you pull the thread to close the seam, be careful not to pucker the seam.

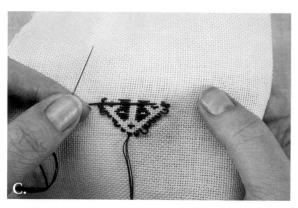

C.

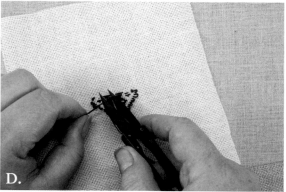

D.

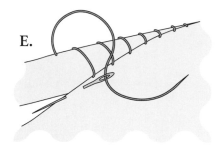

E.

Ladder stitch

Note: Don't Pucker Up

If your seam puckers, you have pulled your thread too tightly, or your stitches are too large, or far apart. Take the time to do it right and don't be afraid to take out stitches until you find the thread tension and stitch size that is right for your fabric.

▌ OVERCAST STITCH

1. Insert your needle through the fabric from back to front, just a few threads from the cut edge.

2. Pull the needle and thread through the fabric, leaving a long tail or knot. *fig. F*

3. Pass the needle to the back of the fabric and move it along the fabric edge, advancing no further than a few threads. *fig. G*

4. Come up through the fabric from back to front as before. *fig. H*

5. Pull the needle and thread, and gently snug the resulting diagonal loop so it holds but does not pull the edge threads. *fig. I*

6. Continue until you have secured all of the cut edges of your fabric.

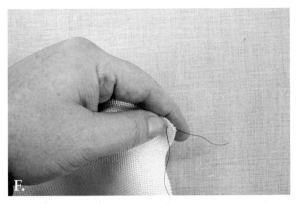

▌FINISHING EDGES

Covered Edges

For projects like the pillows, wallhanging, and placemats, the overcast edges of evenweave fabric are encased inside a seam where the evenweave is sewn to another piece of fabric. In these cases, the edges are secured by both an overcast stitch and stitched seam. And, because those seams are turned to the inside of the project, they will not experience any stress from the outside. No additional edge finishing is necessary.

Evenweave overcast edge sewn to other woven fabric.

Finished sewn seam with edges turned in.

Fray It Out

A frayed look edging adds texture and character to projects like bookmarks and fabric patches. To achieve this look, add a seam allowance around your stitched area equal to the length of the desired fraying. If you want 1″ of fraying, sew an overcast, zigzag, or back-stitch 1″ from the cut edge of the evenweave fabric.

Once the threads 1″ from the edge are secured, use a thread pick or tweezers to pull the threads running parallel to the cut edges and sewn lines. The frayed edge is complete and can be left as is, or wash and dry the fabric (according to the fiber content) to further fray the threads for a fluffier look.

Finished frayed edge.

Folded Edge

For bookmarks, framed art pieces, and other projects where you might want a finished edge, fold the seam allowance to the back side of the finished kogin fabric.

1. Secure the folded edge with clips or pins.

2. Sew an overcast stitch or straight stitch (depending on the effect wanted) close to the edge of the folded fabric. Or, for variety, you could use a regular sashiko running stitch or a blanket stitch. We usually keep this to about ⅛″ from the edge.

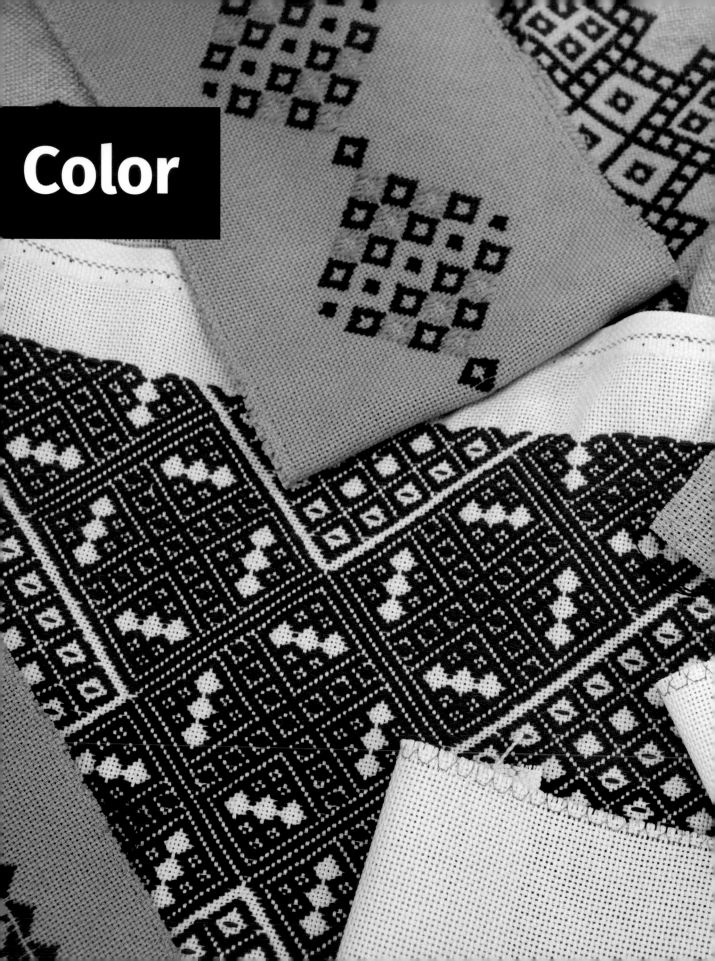

Color

Traditional kogin-zashi designs were worked in white thread on indigo-dyed fabric. While this is an iconic representation of kogin, and one of our favorites, there are examples of original kogin using colored threads. Certainly, modern kogin designers and stitchers are not limited by the availability of colors of threads or fabric. And, while we used certain colors in the projects in this book, we encourage you to play with colors of fabric and threads and definitely experiment on your own practice swatches with color-blending and color-blocking techniques. Even small adjustments can make a big difference to an overall project and give your pieces a look that is unique to you. There is no right or wrong when it comes to color choices. Use the colors that bring you joy!

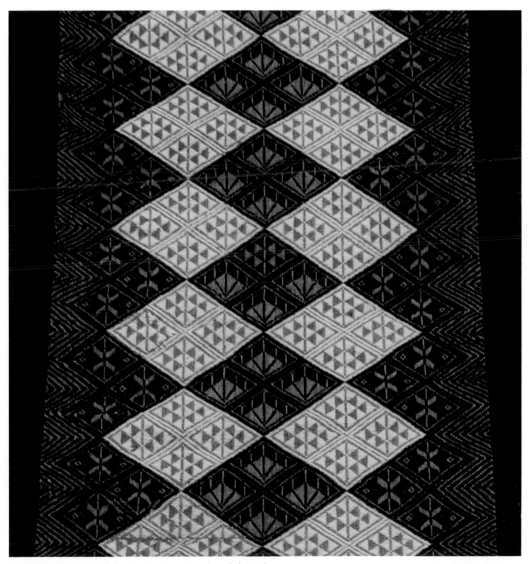

Traditional apron with kogin stitching in colored thread.
Photo courtesy of the Seattle Art Museum

LANGUAGE

To ensure we are all speaking the same language, here is a guide for how we talk about thread blending and color work.

When working with multiple colors, each color is labeled with a letter in order of use: Color A, Color B, Color C, and so on. For example, a stitch pattern using three colors of blue would include the colors listed in the materials list as:

Color A: Dark blue, color #XX

Color B: Mid-weight blue, color #XX

Color C: Light blue, color #XX

We will use this shorthand whether the pattern uses color blending that shimmers from dark blue to mid-weight blue to light blue or color blocking where each color is used independently.

■ Color Blending

Color blending is the slow blending of colors that are very close to one another in value and color family. This technique is used to create a shimmer effect where the colors intensify and lighten in waves across the stitch pattern. Color blending also creates ombré or gradients of color. Either of these effects is accomplished by gradually substituting thread strands of the next color in the sequence with the starting color. How quickly you substitute the new strands of color determines how gradual and subtle the color change appears. Choose your starting color and ending color, then find one or two middle colors that bridge those two. The more color steps you have between your starting and ending colors, the more nuanced your color changes will be. By adding strands of Color B to your Color A thread/floss bundle, you transition between the two colors. Transition areas are indicated in the patterns as T_1, T_2, and so on.

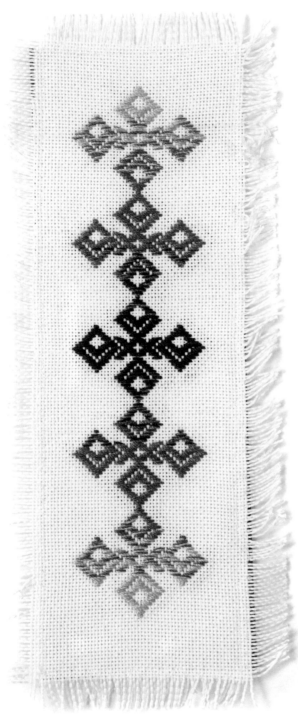

Color blending gives a shimmer effect moving gradually between closely related colors.

Charts with color blending include green lines to indicate the colors used and the transition areas between those colors.

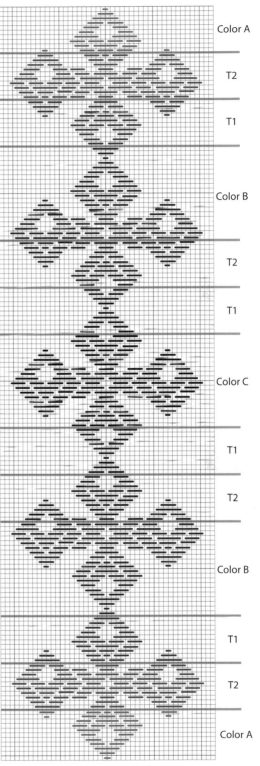

Color A

T2

T1

Color B

T2

T1

Color C

T1

T2

Color B

T1

T2

Color A

Stitch pattern from Bookmarks (page 124) with accompanying color work chart.

When referring to strands of floss or 12-weight thread as color is shifted from one to the next, the stitch chart includes lines where we made our color changes. Those lines are labeled with Color A, Color B, Color C, and so on. Between those main color areas, there are transition zones marked with a "T" followed by numbers 1, 2, 3 depending on the number of color changes in that chart. The number shown represents the number of threads of each color used in that particular transition zone.

For example, using 6 strands of floss, color blending from Color A to Color B looks like this:

T1 = 2 of Color A, 4 of Color B

T2 = 4 of Color A, 2 of Color B

Using 3 strands of 12-weight thread, color blending from Color A to color B is labeled like this:

T1 = 2 strands of Color A, 1 strand of Color B

T2 = 1 strand of Color A, 2 strands of Color B

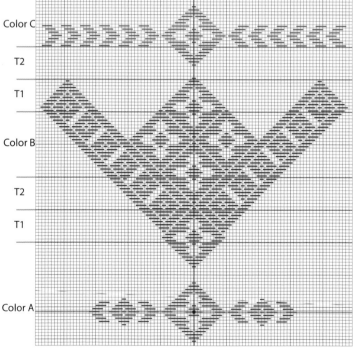

Stitch chart with lines labeled for color changes using 12–weight thread.

Color Blocking

Rather than a subtle color difference over an entire pattern, color blocking is a pop of color over a particular section of an overall stitch pattern. This creates an effect that can spotlight sections of your pattern that you want to stand out or, conversely, fade into the base fabric. Either high-contrast colors or closely related colors can be used to add depth and excitement to an overall kogin stitch pattern.

Again, color is a very personal form of expression. Any colors we have used are indicative of our (current) color favs. Your own projects should reflect you and your style so don't be shy about switching it up and trying different combinations of fabric and thread colors. It is entirely up to you and your imagination. Again, there is no right or wrong when it comes to color. If a color or color combination brings you joy, then that is all that's important.

Pro Tip: Do It Yourself!

While we were writing this book, many colors of evenweave were either not available or simply didn't exist. GAH! Rather than make do with what was available, we dyed our own colors to suit our needs using easy-to-find craft-store fabric dyes.

Color blocking

KOGIN-ZASHI
Stitch Library

We have not included all of the current modoco as listed by the Hirosaki Kogin Institute or on the Koginbank websites.

Instead, we have included the modoco (motifs) we use most frequently, as well as a few of our favorites that we wanted to include just because we thought you might enjoy using them or substituting them in your own projects.

We also included motifs and stitch patterns that we created ourselves based on kogin-zashi techniques. These do not always follow the strict rules of traditional kogin-zashi but, instead, they hold true to the spirit of kogin-zashi and express our creativity through the medium of kogin-zashi. We invite you to visit Koginbank online and dive deeper into their list of historical modoco.

Tip: Easy Reading

To make reading these stitch charts easier, you can go to **tinyurl.com/11482-patterns-download** and print them out or download them to your computer or mobile device. If you see a pattern that is divided into quarters or halves, you can download the tiled version and create a single, large pattern for use on your computer or mobile device, or you can print a tiled version of the chart on standard paper and tape them together. You can also be really fancy and take the file to your local copy shop to have the chart printed full size. Our favorite method is to download the chart to our mobile devices and enlarge them for easy reading.

Basic Modoco

The basic modoco are the base characters from which most of the stitch patterns in this book are created. Learning these smaller stitch patterns will give you a head start on the more complicated patterns to come.

BASIC MODOCO SET 1

A. Count: 3 × 3. See Modocos A, B, and C stitched in combination with other motifs in Bookmarks (page 124).

B. Count: 5 × 5

C. Count: 7 × 7

D. Count: 7 × 7

E. Count: 9 × 9

F. Count: 11 × 11

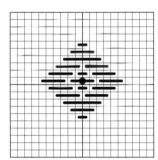

G. Count: 11 × 11

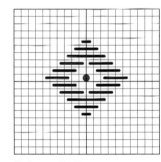

H. Count: 11 × 11

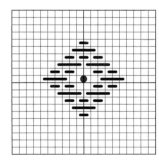

I. Count: 11 × 11

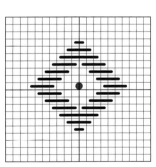

J. Count: 13 × 13

▌ BASIC MODOCO SET 2

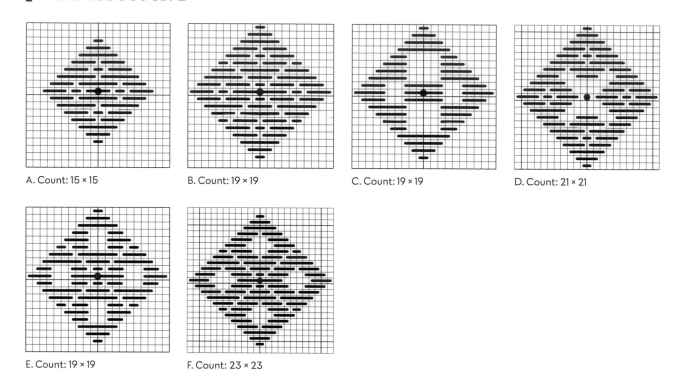

A. Count: 15 × 15

B. Count: 19 × 19

C. Count: 19 × 19

D. Count: 21 × 21

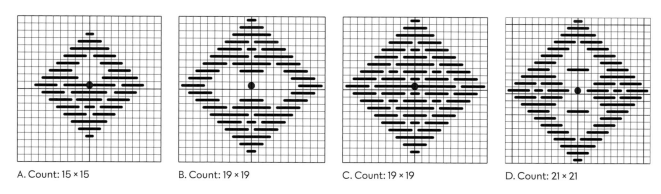

E. Count: 19 × 19

F. Count: 23 × 23

▌ BASIC MODOCO SET 3

A. Count: 15 × 15

B. Count: 19 × 19

C. Count: 19 × 19

D. Count: 21 × 21

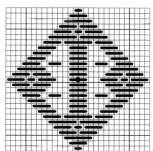

Count: 27 × 27

BASIC MODOCO SET 4

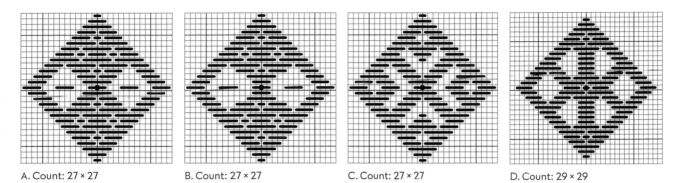

A. Count: 27 × 27 B. Count: 27 × 27 C. Count: 27 × 27 D. Count: 29 × 29

BASIC MODOCO SET 5

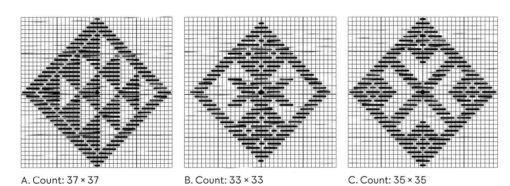

A. Count: 37 × 37 B. Count: 33 × 33 C. Count: 35 × 35

Secondary Modoco

Slightly more complicated than the Basic Modoco, these stitch patterns start combining some of the base characters with the addition of lines creating angles.

SECONDARY MODOCO SET 1

A. Count: 15 × 17. See this Modoco stitched in combination with other motifs in Bookmarks (page 124).

B. Count: 17 × 15

C. Count: 19 × 19

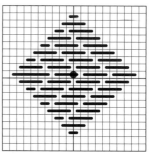

D. Count: 17 × 17

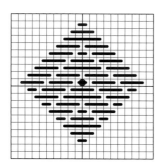

E. Count: 17 × 17

SECONDARY MODOCO SET 2

A. Count: 19 × 19

B. Count: 19 × 19

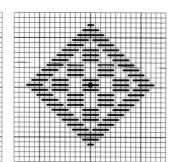

C. Count: 25 × 25

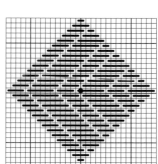

D. Count: 29 × 29

SECONDARY MODOCO SET 3

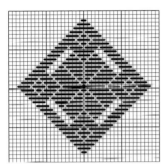

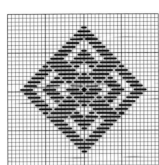

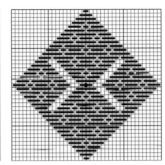

A. Count: 35 × 35

B. Count: 33 × 33

C. Count: 39 × 39

SECONDARY MODOCO SET 4

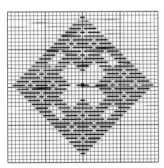

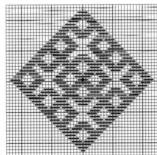

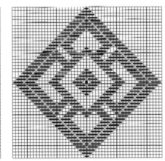

A. Count: 37 × 37. See a stitched sample in Wallhanging (page 150).

B. Count: 47 × 47. See a stitched sample in Wallhanging (page 150).

C. Count: 49 × 49

Tiled Modoco

Repeating a Basic Modoco and/or Secondary Modoco pattern in a grid or a line will create a tiled effect. These are simple patterns that look spectacular when seen as a whole. Consider using tiled modoco as borders around your artwork!

TILED MODOCO SET 1

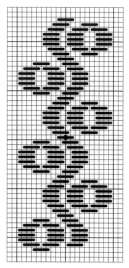

A. Count as shown: 19 × 48

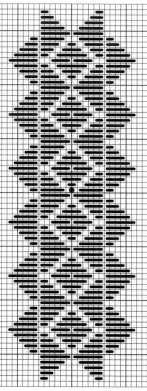

C. Count as shown: 23 × 69

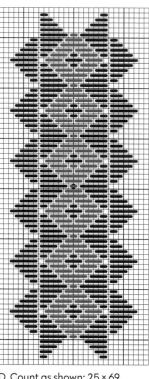

D. Count as shown: 25 × 69.
See stitched samples in Mug
Rug / Coaster Set (page 131) and
Placemats (page 134).

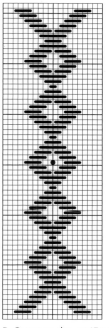

B. Count as shown: 15 × 61

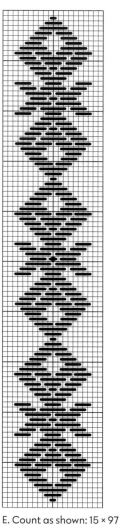

E. Count as shown: 15 × 97

▍TILED MODOCO 2

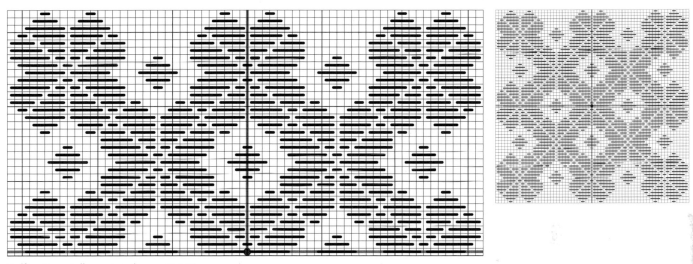

Half pattern. Full count as shown: 65 × 63

▍TILED MODOCO 3

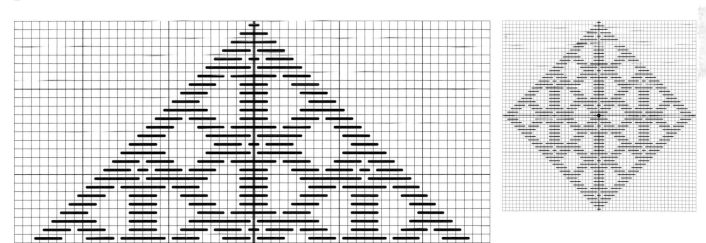

Half pattern. Full count as shown: 55 × 55.

▍TILED MODOCO 4

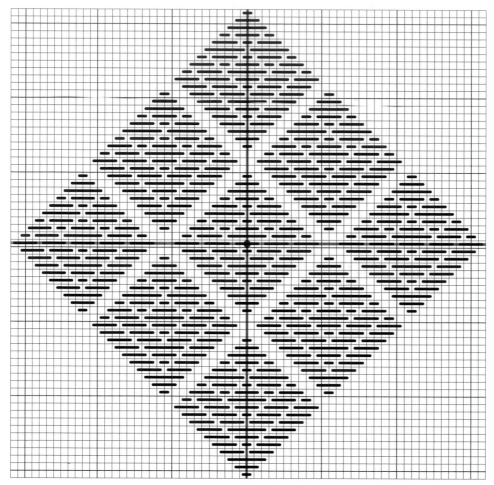

Count as shown: 63 × 63

▍TILED MODOCO 5

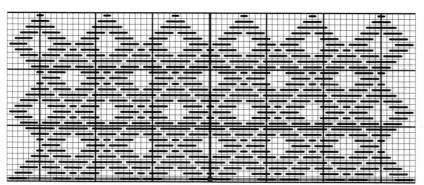

Half pattern. Full count as shown: 71 × 59

TILED MODOCO 6

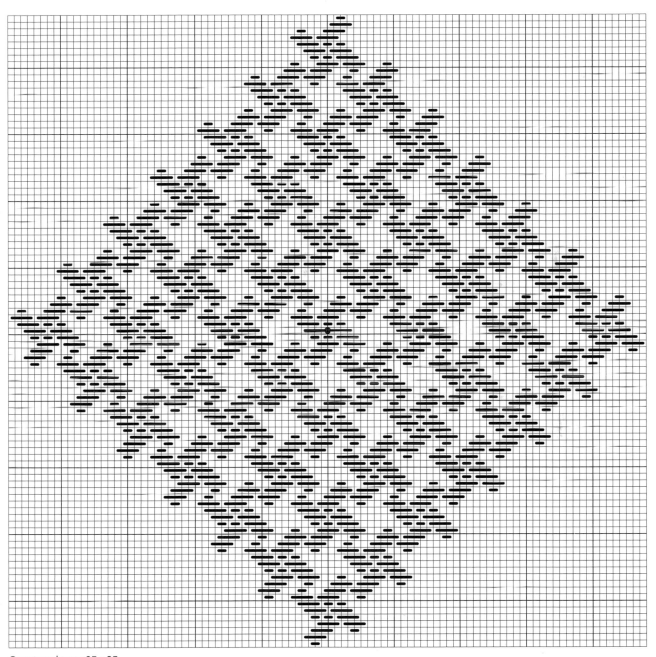

Count as shown: 95 × 95

▮ TILED MODOCO 7

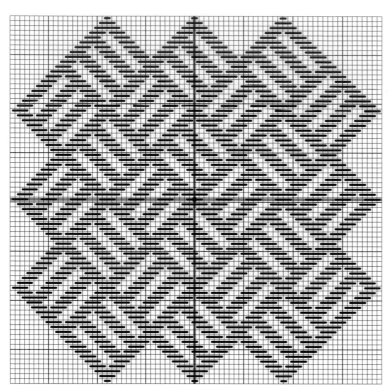

Count as shown: 75 × 75. See stitched samples in Mug Rug / Coaster Set (page 131) and Placemats (page 134).

▮ TILED MODOCO 8

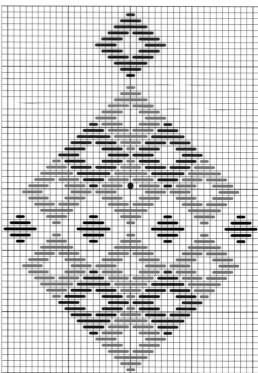

Count as shown: 41 × 59. See stitched samples in Bookmarks (page 124), Mug Rug / Coaster Set (page 131), and Placemats (page 134).

TILED MODOCO 9

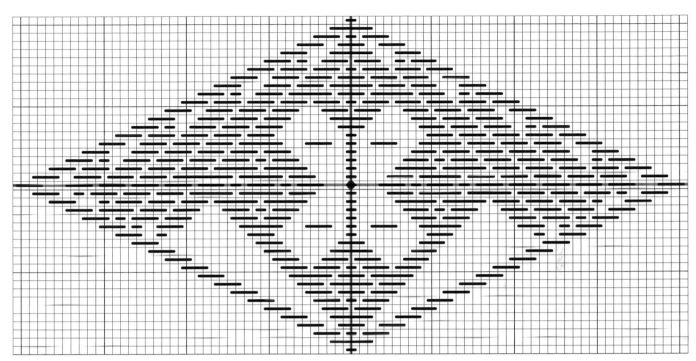

Count: 81 × 41

TILED MODOCO 10

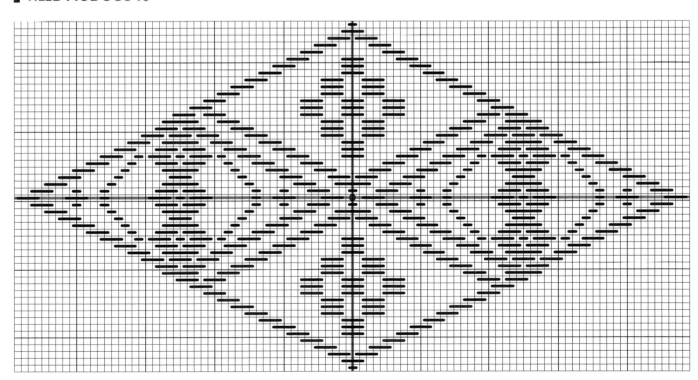

Count: 97 × 51

TILED MODOCO 11

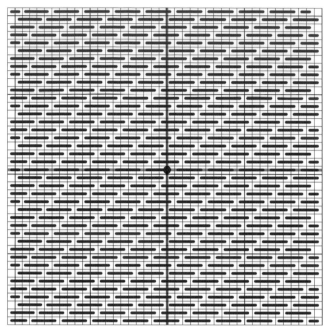

Count as shown: 40 × 40. See stitched samples in Mug Rug / Coaster
Set (page 131) and Placemats (page 134). To cover larger areas, just continue the pattern.

TILED MODOCO 12

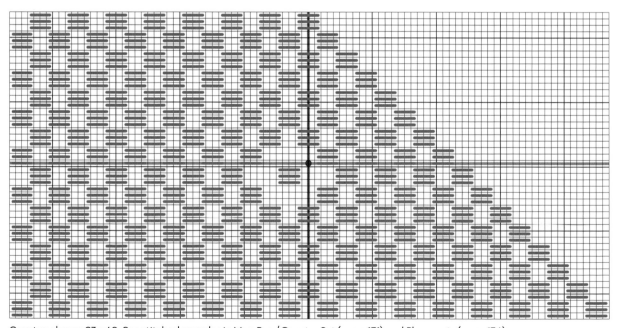

Count as shown: 93 × 48. See stitched samples in Mug Rug / Coaster Set (page 131) and Placemats (page 134).

▌LOOKIN' AT PILLOW REPEAT CHART 1

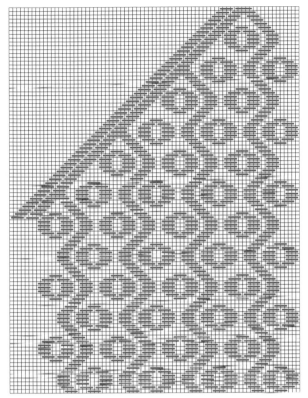

Right edge repeat.

▌LOOKIN' AT PILLOW REPEAT CHART 2

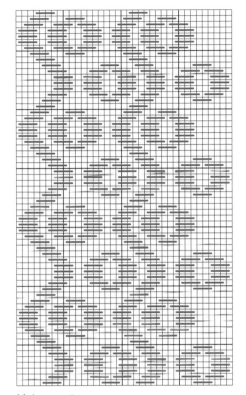

Main repeat.

▌LOOKIN' AT PILLOW REPEAT CHART 3

Left edge repeat.

▌ TILED MODOCO 13 / LOOKIN' AT PILLOW FULL CHART

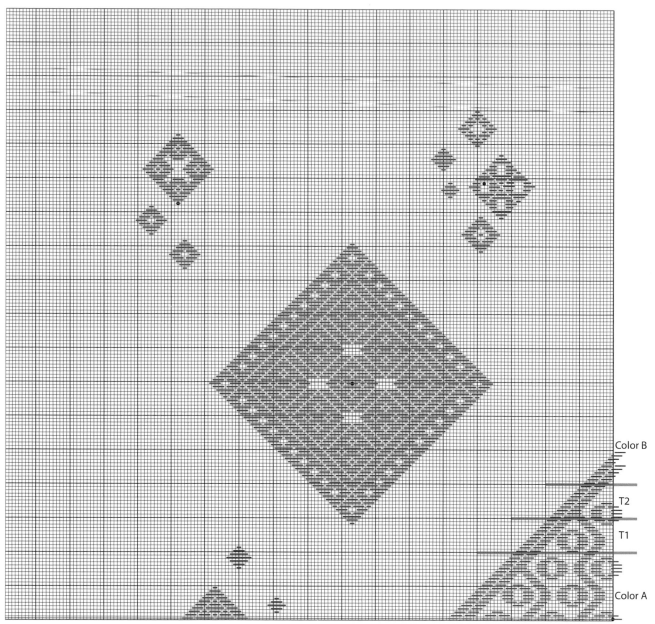

Top left quadrant count 180 × 180. Full count: 360 × 360. See the other quadrants on the following pages. See the stitched pillow (page 147). Refer to Repeat Charts 1–3 and Pillow Clusters 1–5 (page 90 and pages 85–89) for closeups of the motif patterns. See Floats (page 46) for more information about how to stitch the individual clusters at the top left.

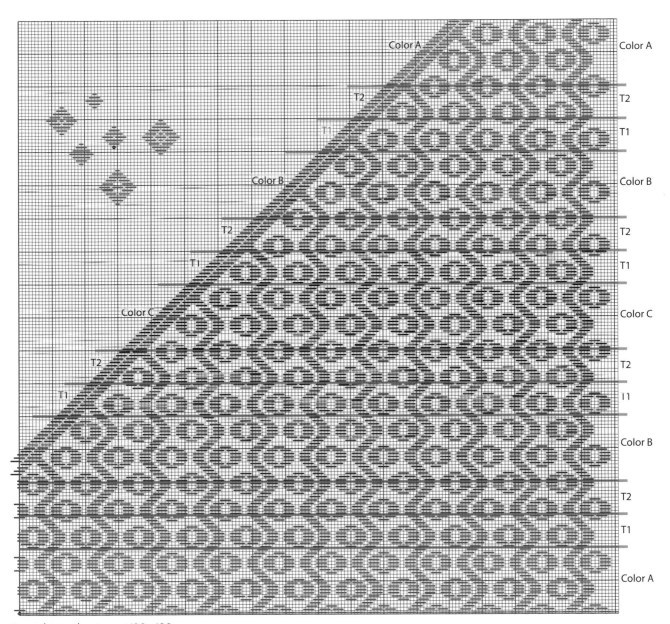

Color A
T2
T1
Color B
T2
T1
Color C
T2
T1
Color B
T2
T1
Color A

Top right quadrant count 180 × 180

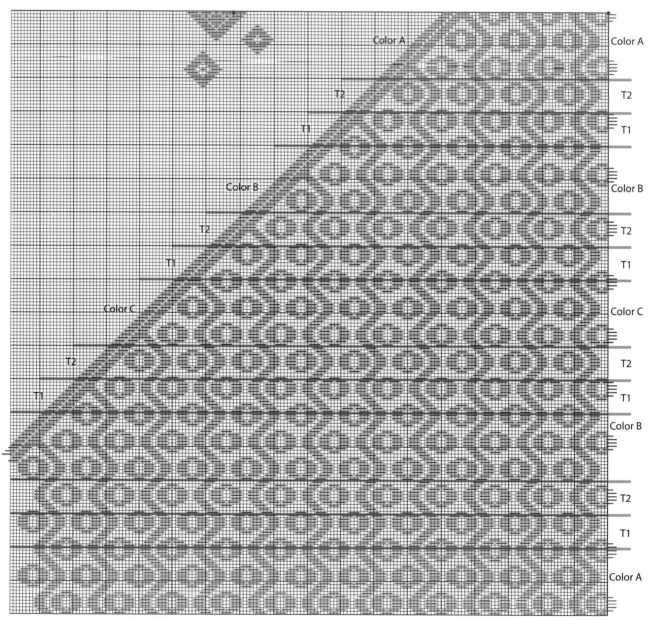

Bottom left quadrant count 180 × 180

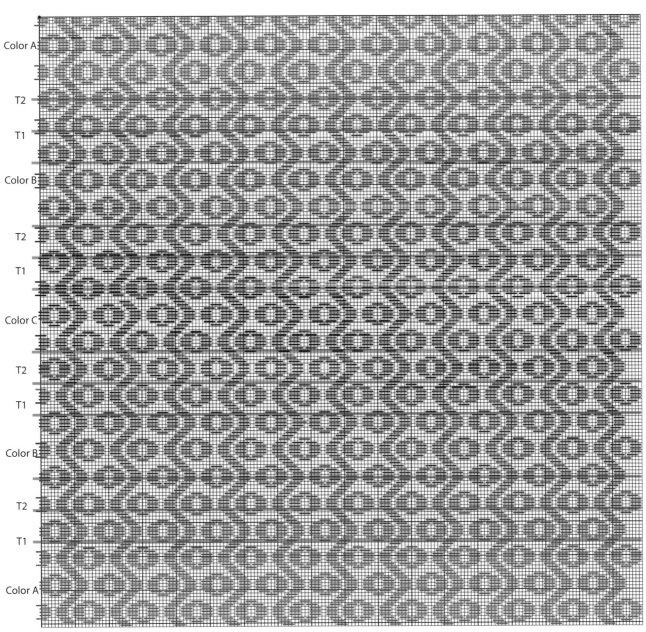

Color A

T2

T1

Color B

T2

T1

Color C

T2

T1

Color B

T2

T1

Color A

Bottom right quadrant count 180 × 180

▐ LOOKIN' AT PILLOW CLUSTER 1

See Floats (page 46) for how to stitch the clusters.

Count: 23 × 40

▐ LOOKIN' AT PILLOW CLUSTER 2

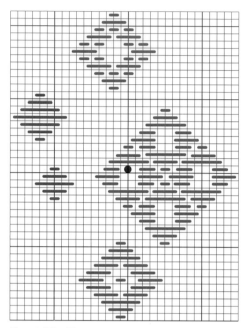

Count: 30 × 42

▐ LOOKIN' AT PILLOW CLUSTER 3

Count: 40 × 34

▐ LOOKIN' AT PILLOW CLUSTER 4

See Stand-Alone Combination 13 / Pillow Cluster 4 (page 95).

▐ LOOKIN' AT PILLOW CLUSTER 5

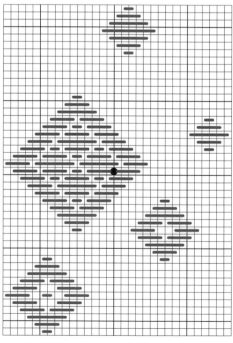

Count: 30 × 45

Stand-Alone Combinations

Combining smaller modoco into larger stitch patterns is the first major step for most kogin-zashi stitchers. Here are a few of our favorites. Some are historical patterns and others are our own creations.

STAND-ALONE COMBINATION 1

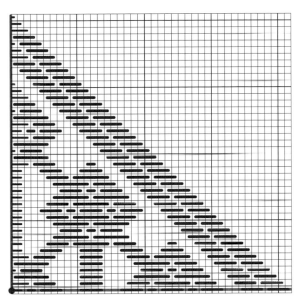
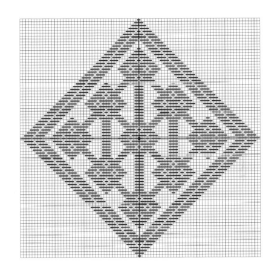

Quarter pattern. Count for full pattern: 63 × 63 without border, 83 × 83 with border. See stitched samples in Mug Rug / Coaster Set (page 131) and Placemats (page 134).

STAND-ALONE COMBINATION 2

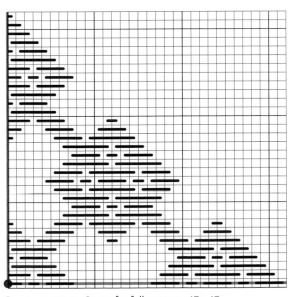
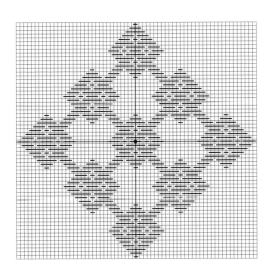

Quarter pattern. Count for full pattern: 63 × 63

▍ STAND-ALONE COMBINATION 3

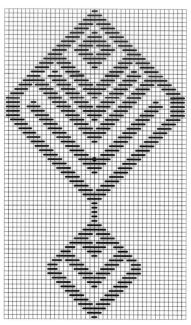

▍ STAND-ALONE COMBINATION 4

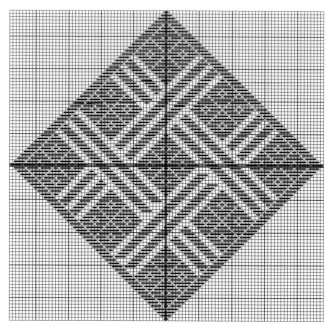

Count: 41 × 71. See an overall pattern from this motif repeated in Peacock Jacket (page 164).

Count: 95 × 95

▍ STAND-ALONE COMBINATION 5

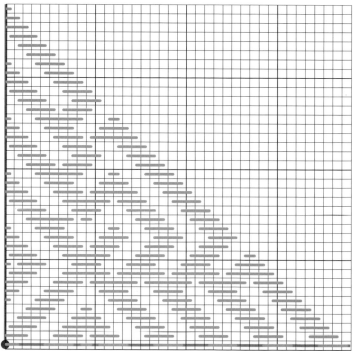

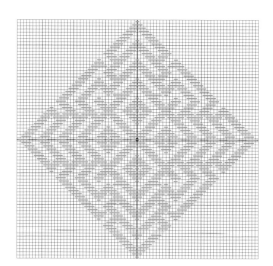

Quarter pattern: Full count: 75 × 75.

▍ STAND-ALONE COMBINATION 6

Count: 43 × 41. See a stitched sample in Wallhanging (page 150).

▍ STAND-ALONE COMBINATION 7

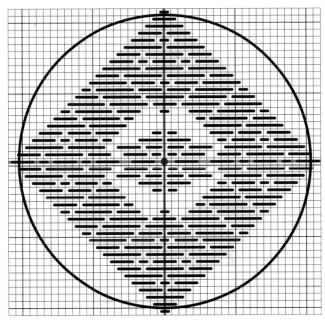

Count: 43 × 43. See a stitched sample in Wallhanging (page 150).

▍ STAND-ALONE COMBINATION 8

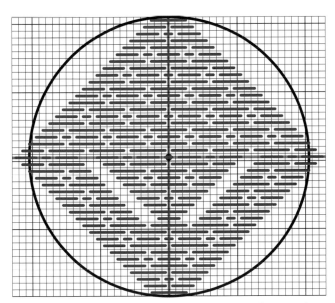

Count: 45 × 41. See a stitched sample in Wallhanging (page 150).

▍ STAND-ALONE COMBINATION 9

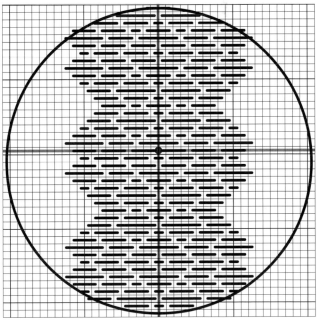

Count: 25 × 42.

▌ STAND-ALONE COMBINATION 10

▌ STAND-ALONE COMBINATION 11

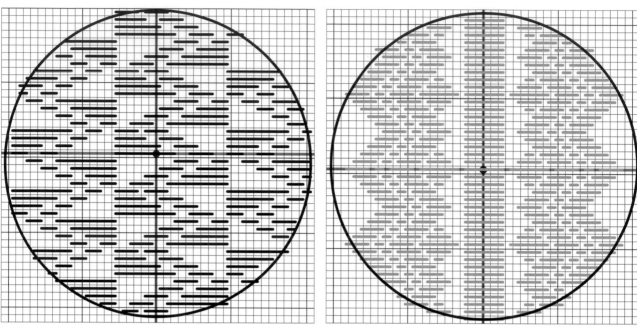

Count: 41 × 41

Count: 37 × 41. See a stitched sample in Wallhanging (page 150).

▌ STAND-ALONE COMBINATION 12

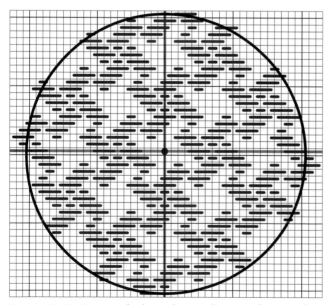

Count: 45 × 43. See a stitched sample in Wallhanging (page 150).

▌ STAND-ALONE COMBINATION 13 / LOOKIN' AT PILLOW CLUSTER 4

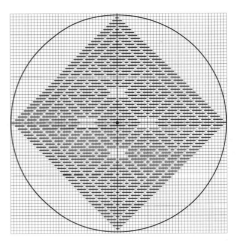

Quarter pattern. Full count: 71 × 71. See stitched samples in Wallhanging (page 150) and Lookin' at Pillow (page 147).

▌ STAND-ALONE COMBINATION 14

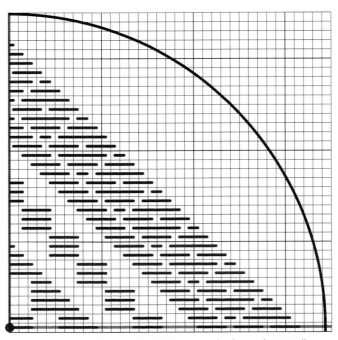

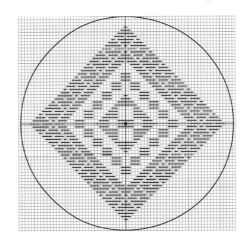

Quarter pattern. Full count: 61 × 63. See a stitched sample in Wall-hanging (page 150).

STAND-ALONE COMBINATION 15

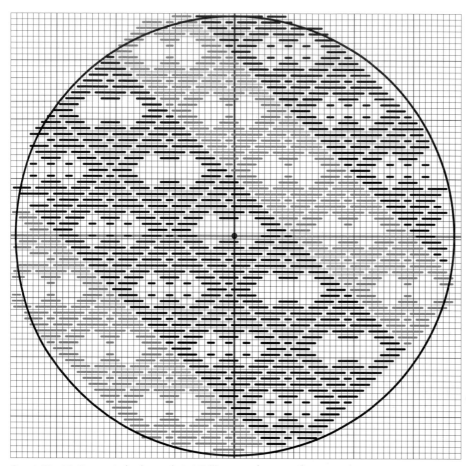

Count: 74 × 74. See a stitched sample in Wallhanging (page 150).

STAND-ALONE COMBINATION 16

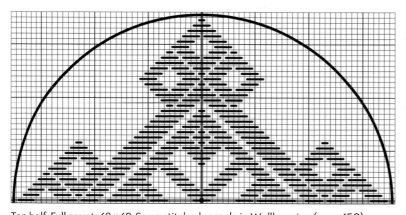

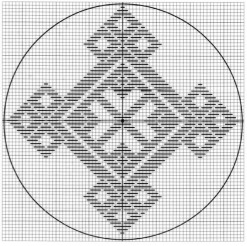

Top half. Full count: 69 × 69. See a stitched sample in Wallhanging (page 150).

▌ STAND-ALONE COMBINATION 17

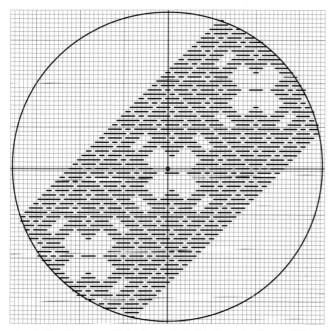

Count: 69 × 69. See a stitched sample in Wallhanging (page 150).

▌ STAND-ALONE COMBINATION 18

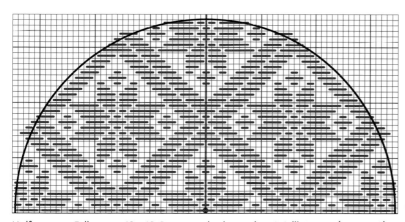
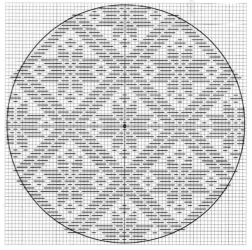

Half pattern. Full count: 69 × 69. See a stitched sample in Wallhanging (page 150).

▌ STAND-ALONE COMBINATION 19

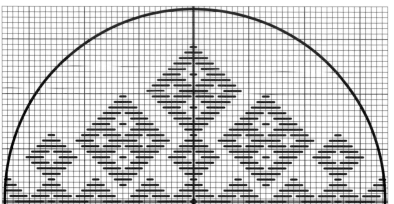

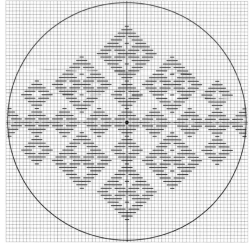

Half pattern. Full count: 69 × 57. See a stitched sample in Wallhanging (page 150).

▌ STAND-ALONE COMBINATION 20

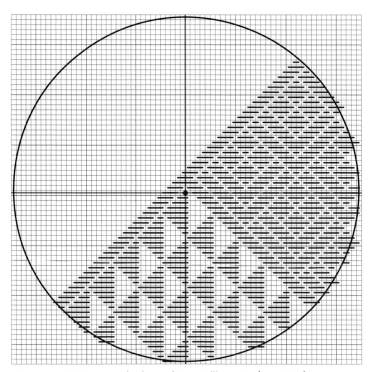

Count: 62 × 61. See a stitched sample in Wallhanging (page 150).

▌STAND-ALONE COMBINATION 21

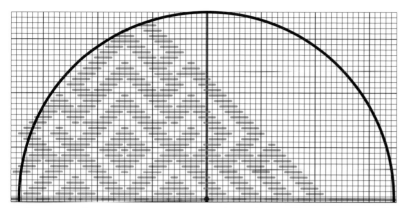
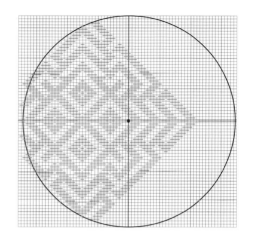

Half pattern. Full count: 58 × 65. See a stitched sample in Wallhanging (page 150).

▌STAND-ALONE COMBINATION 22

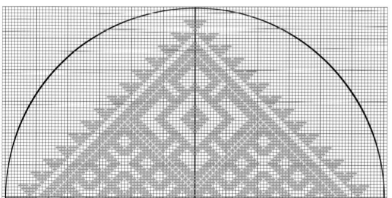
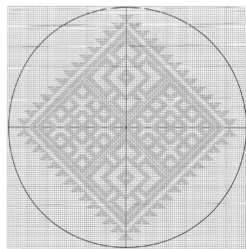

Half pattern. Full count: 111 × 113. See a stitched sample in Wallhanging (page 150).

STAND-ALONE COMBINATION 23

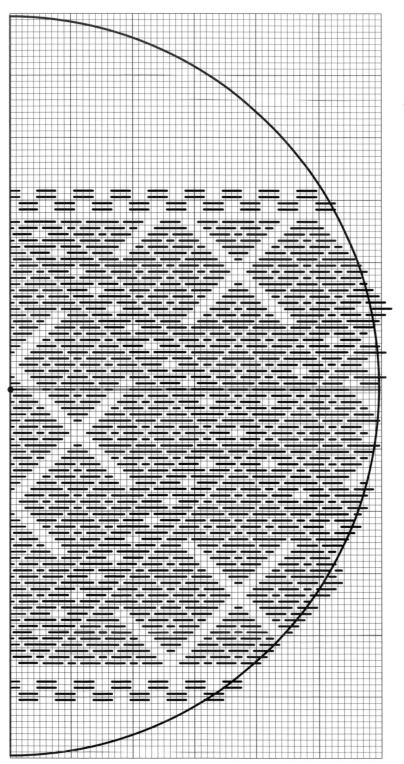
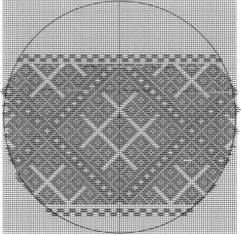

Half pattern. Full count: 121 × 83. See a stitched sample in Wallhanging (page 150).

▌STAND-ALONE COMBINATION 24

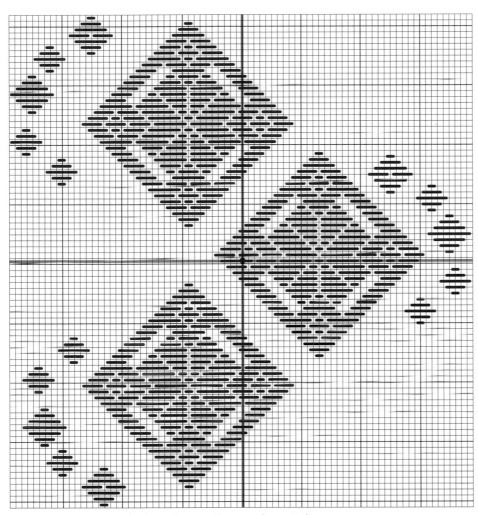

Count: 78 × 83. See a stitched sample in Wallhanging (page 150).

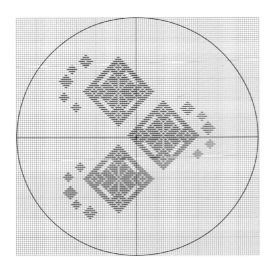

▌ STAND-ALONE COMBINATION 25

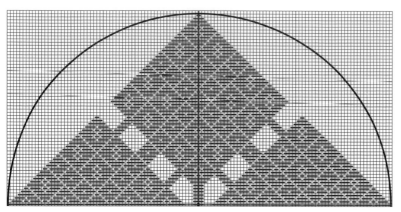

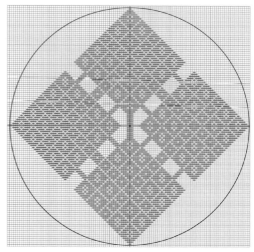

Half pattern. Full count: 120 × 119. See a stitched sample in Wallhanging (page 150).

▌ STAND-ALONE COMBINATION 26

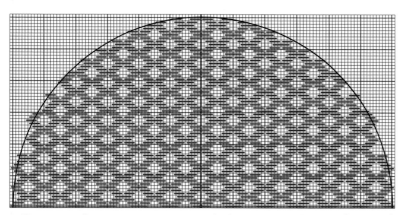

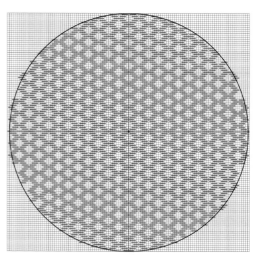

Half pattern. Full count: 120 × 120. See a stitched sample in Wallhanging (page 150).

STAND-ALONE COMBINATION 27

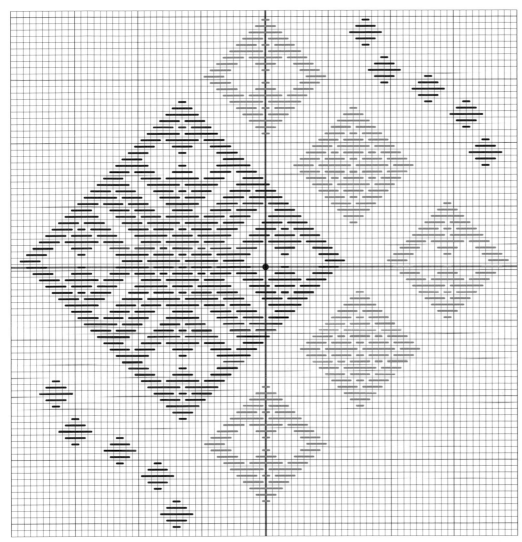

Count: 78 × 81. See a stitched sample in Wallhanging (page 150).

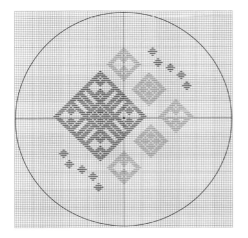

STAND-ALONE COMBINATION 28

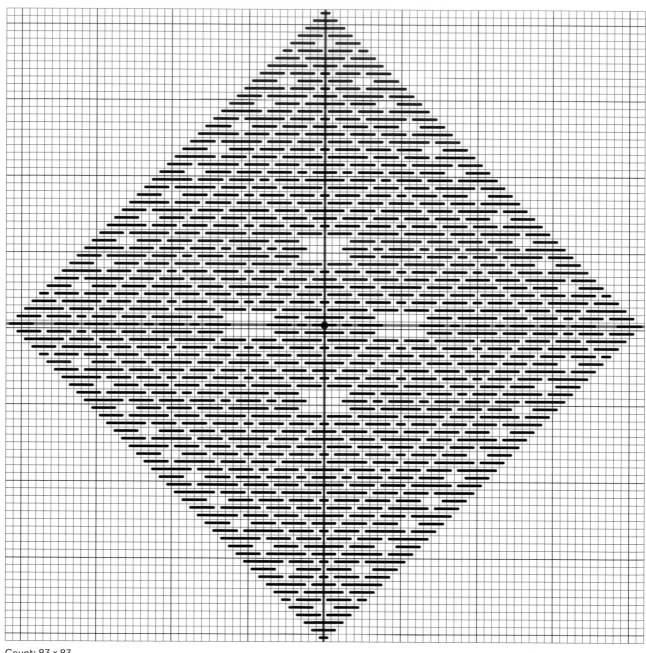

Count: 83 × 83

STAND-ALONE COMBINATION 29

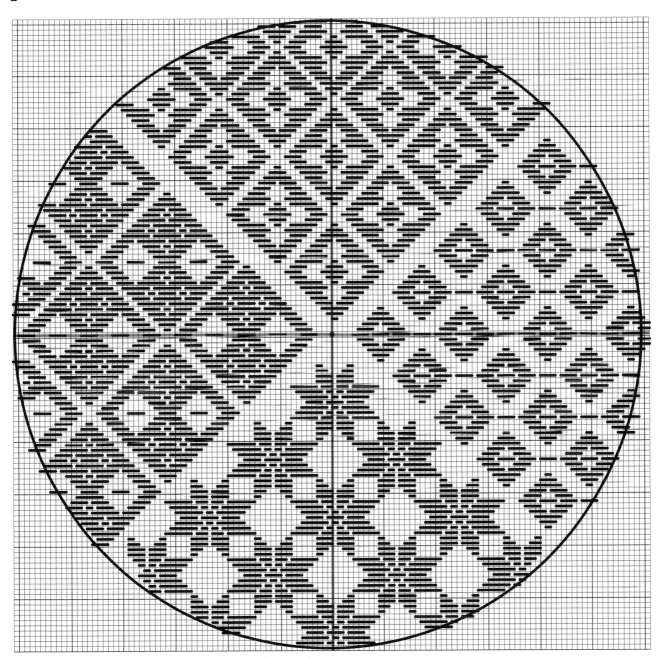

Count: 121 × 121. See a stitched sample in Wallhanging (page 150).

Full-Pattern Stitches

Finally, we offer up the larger groups of stitch patterns we have combined into unique patterns. Many of these patterns are mirror images of the other side across the center lines. In these cases, to save space, only ¼ or ½ of the motif may be provided.

FULL PATTERN 1

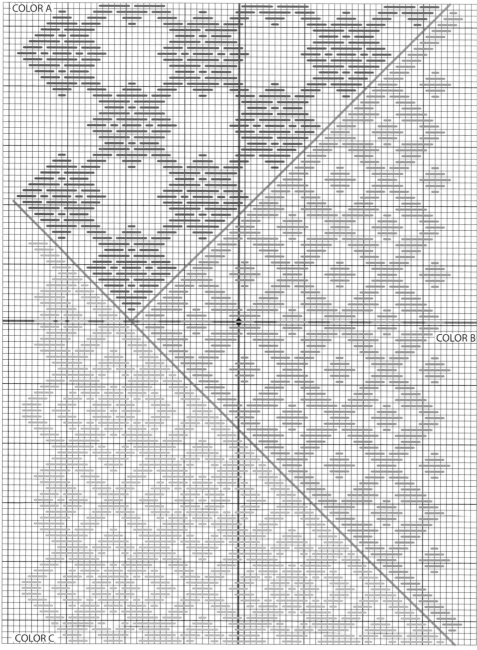

Count: 76 × 108. See a stitched sample in Framed Art (page 127).

FULL PATTERN 2

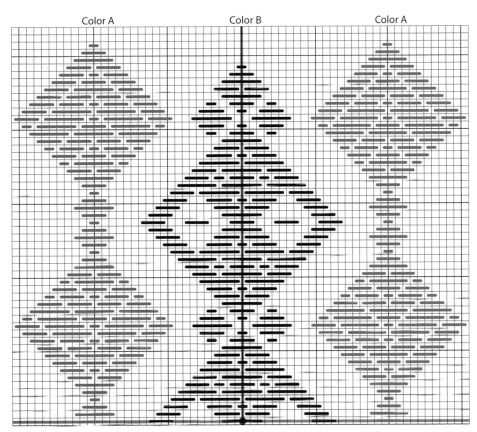

Half pattern. Full count: 61 × 105. See a stitched sample in Framed Art (page 127).

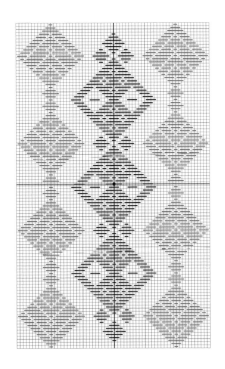

█ FULL PATTERN 3

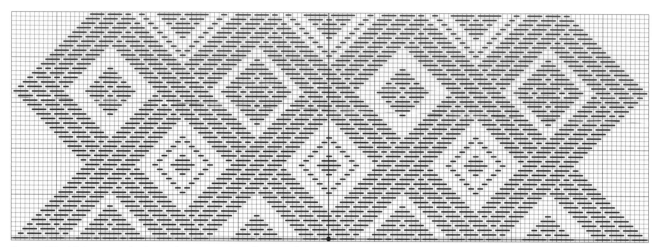

Count: 139 × 99. See a stitched sample in Framed Art (page 127).

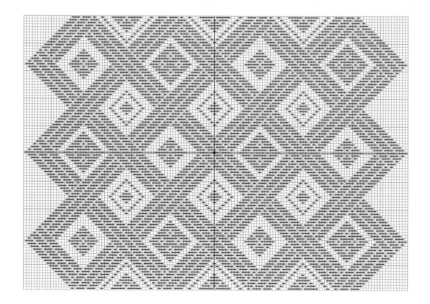

▌ FULL PATTERN 4

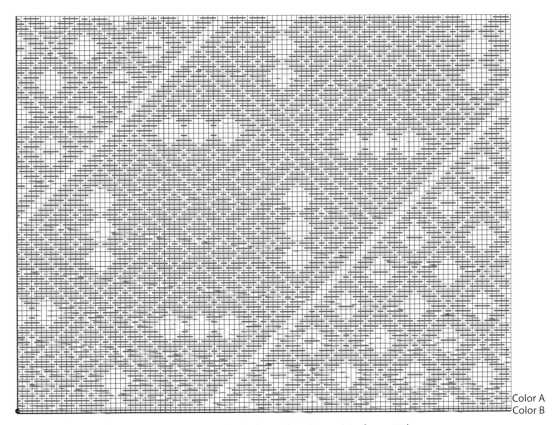

Color A
Color B

Quarter pattern. Full count: 202 × 160. See a stitched sample in Framed Art (page 127).

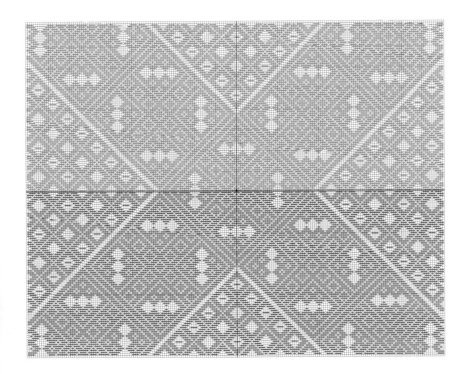

▌ FULL PATTERN 5

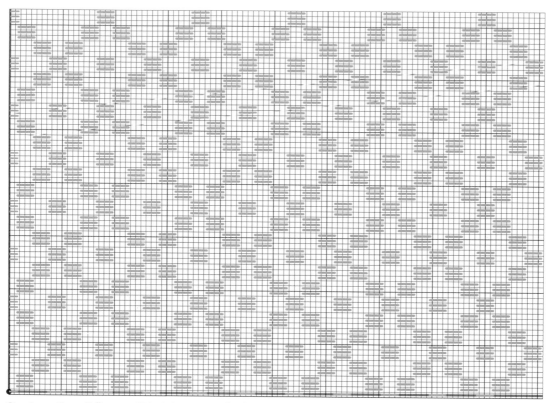

Quarter pattern. Full count: 202 × 147. See a stitched sample in Framed Art (page 127).

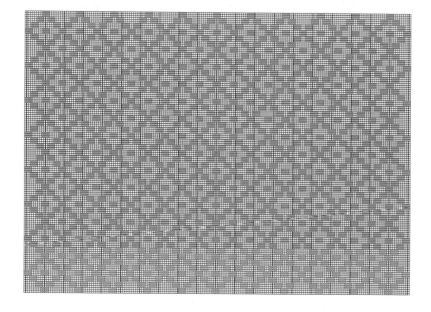

▋ FULL PATTERN 6

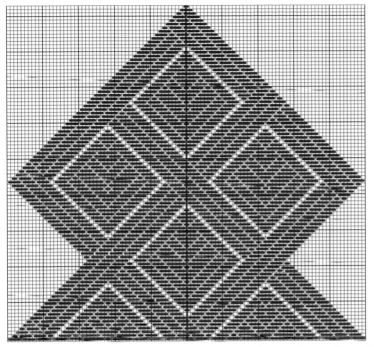
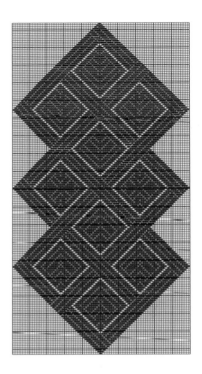

Half pattern. Full count: 100 × 187. See a stitched sample in Book Cover (page 139).

▋ FULL PATTERN 7

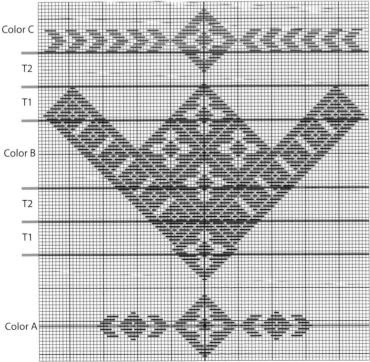
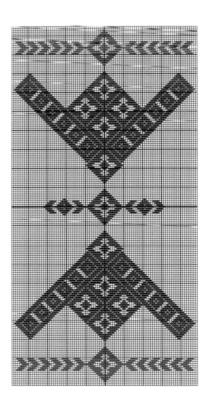

Color C

T2

T1

Color B

T2

T1

Color A

Half pattern. Full count: 97 × 187. See a stitched sample in Take-Along Tote (page 143).

▌ FULL PATTERN 8 / SASHIKO VEST #2 BACK PANEL

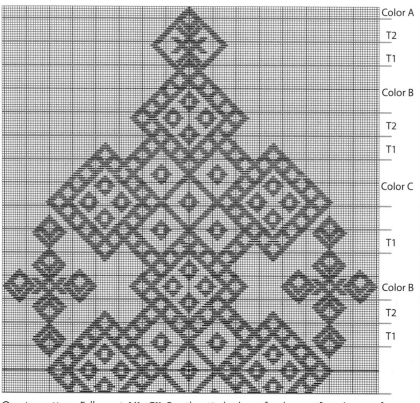

Color A

T2

T1

Color B

T2

T1

Color C

T1

Color B

T2

T1

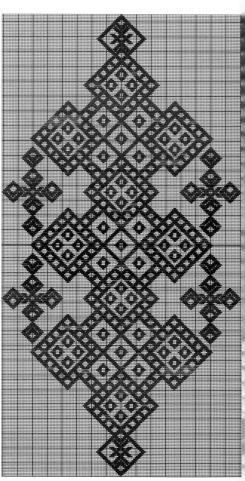

Quarter pattern. Full count: 161 × 311. See the stitched vest for the motifs in the next few patterns (page 155).

FULL PATTERN 9 / SASHIKO VEST #2 COLLAR 1

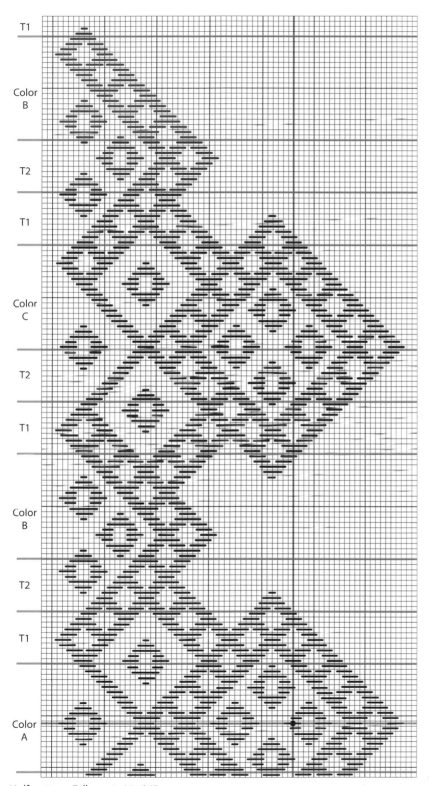

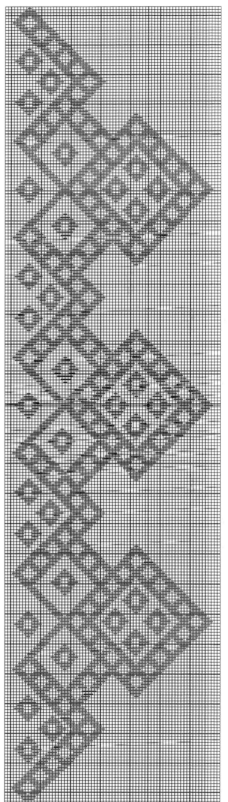

Half pattern. Full count: 66 × 267

▌ FULL PATTERN 10 / SASHIKO VEST #2 COLLAR 2

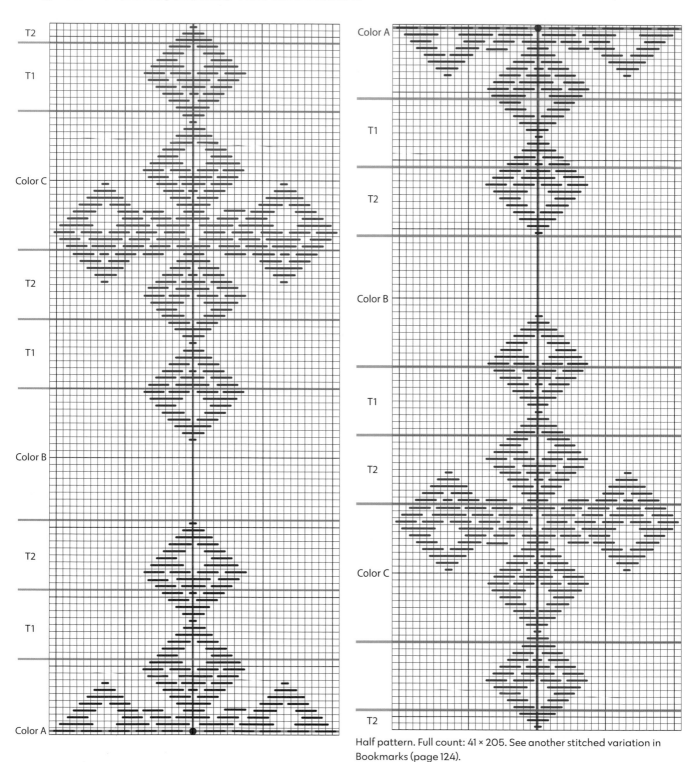

Half pattern. Full count: 41 × 205. See another stitched variation in Bookmarks (page 124).

█ FULL-PATTERN 11A / PEACOCK JACKET BACK PANEL

Choose the finished jacket size (small/medium, large/extra large, or 2X/5X) and stitch the corresponding number of column repeats according to the chart.

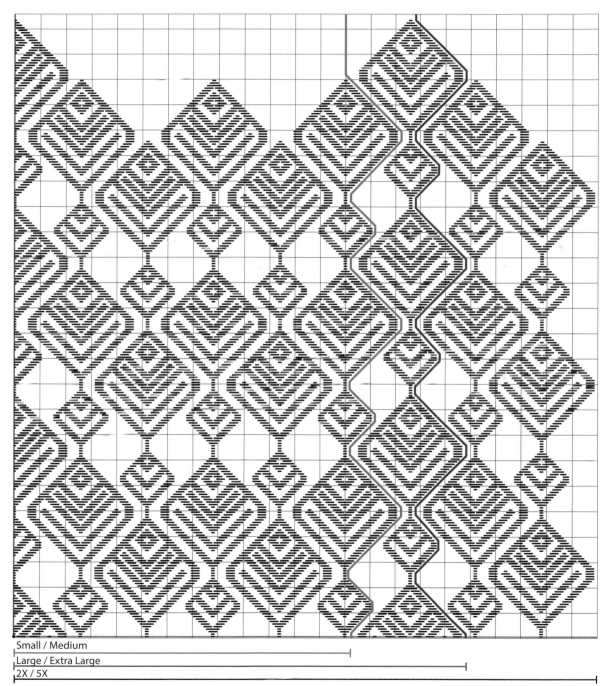

Small / Medium

Large / Extra Large

2X / 5X

Top right quarter. Mirror the image for the left quarter. See the bottom quarter (next page) and the stitched jacket (page 170). Full count: 458 × 445. For up-close looks at the stitch pattern, see the Peacock Jacket back repeat charts (pages 117–118) and Stand-Alone Combinations, Motif 3 (page 92), which shows the individual element that repeats in this design. See Floats (page 46) for more information about how to stitch the elements at the top and bottom that are more than 12 threads apart.

▌ FULL-PATTERN 11B / PEACOCK JACKET BACK PANEL

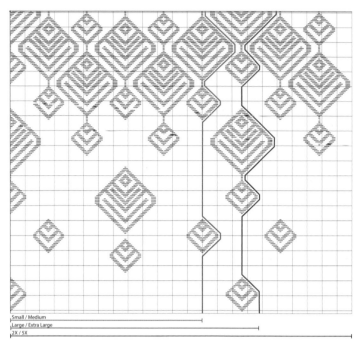

Small / Medium
Large / Extra Large
2X / 5X

Bottom right quarter. Mirror the image for the left quarter. For up-close looks at the stitch pattern, see the Peacock Jacket back repeat charts (pages 115–118) and Stand-Alone Combination 3 (page 92), which shows the individual element that repeats in this design.

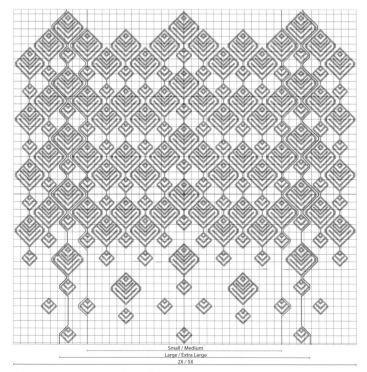

Small / Medium
Large / Extra Large
2X / 5X

Full pattern repeats and size chart

▎PEACOCK JACKET BACK PANEL TOP SECTION AND PANEL COLUMNS REPEATS

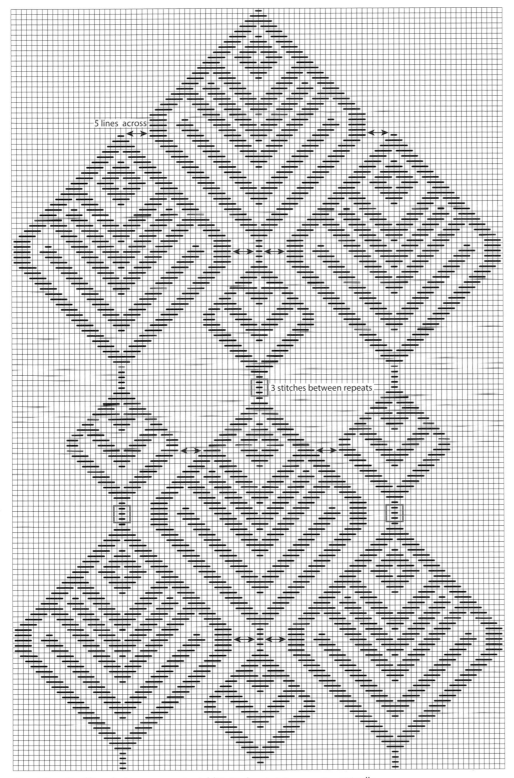

Count 5 vertical lines between repeats. Add 3 stitches to join repeats vertically.

▌PEACOCK JACKET BACK PANEL BOTTOM REPEAT 1

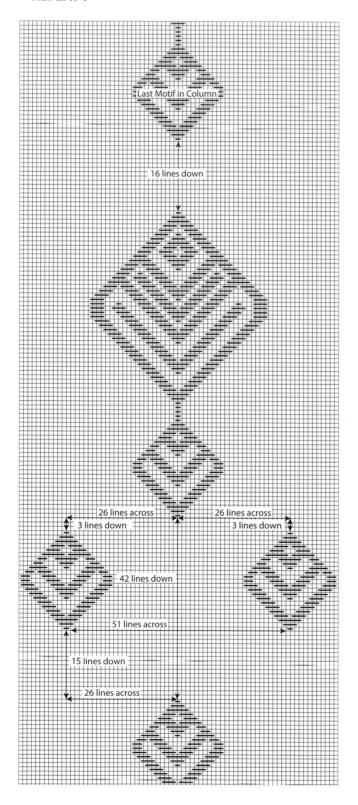

▌PEACOCK JACKET BACK PANEL BOTTOM REPEAT 2

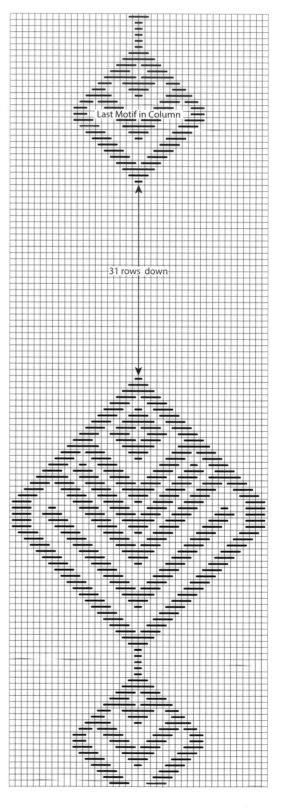

FULL-PATTERN 12 / PEACOCK JACKET COLLAR

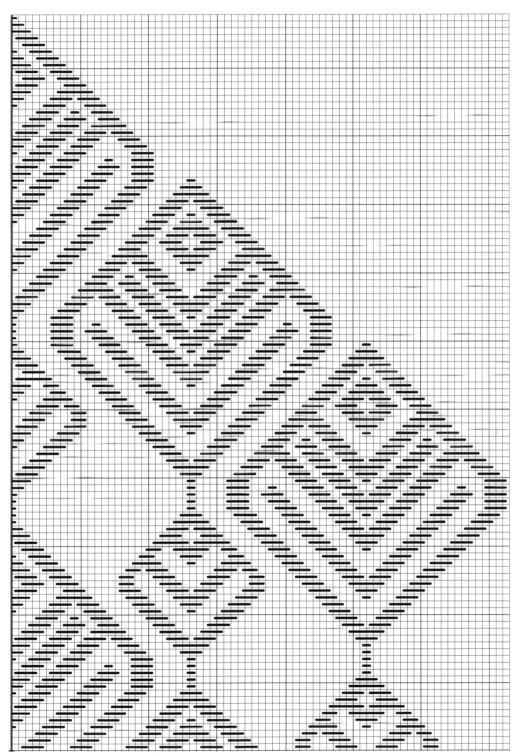

Right top quarter. Full count: 146 × 219. See the bottom pattern (next page). For an up-close look at the stitch pattern, see the individual motif, Stand-Alone Combination 3 (page 92).

▌ FULL-PATTERN 12 / PEACOCK JACKET COLLAR

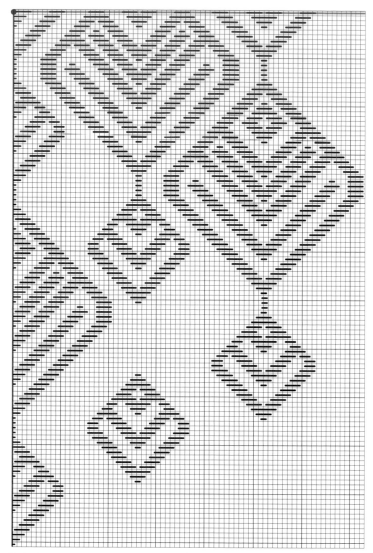

Right bottom quarter

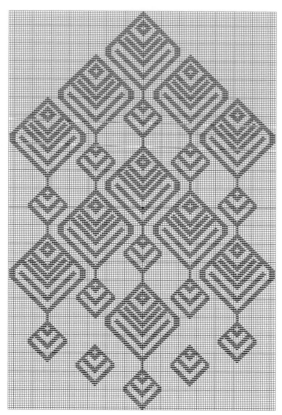

FULL-PATTERN 13 / PEACOCK JACKET CUFF

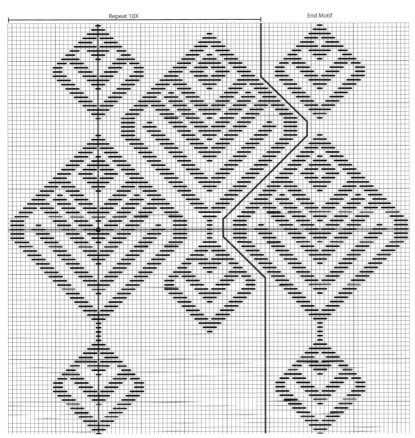

Partial repeat. Full count: 564 × 97. Start at the center. Stitch the partial repeat 10 times, and stitch one end motif. Make 2 cuffs.

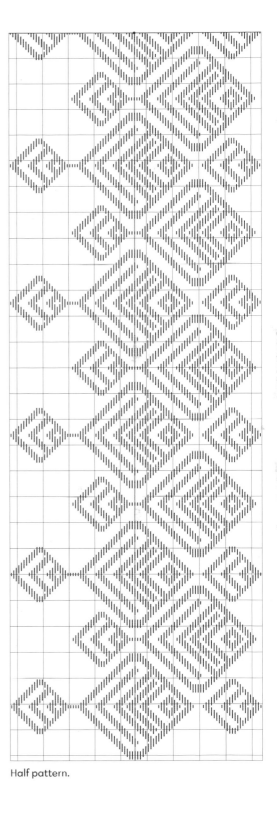

Half pattern.

THE PROJECTS

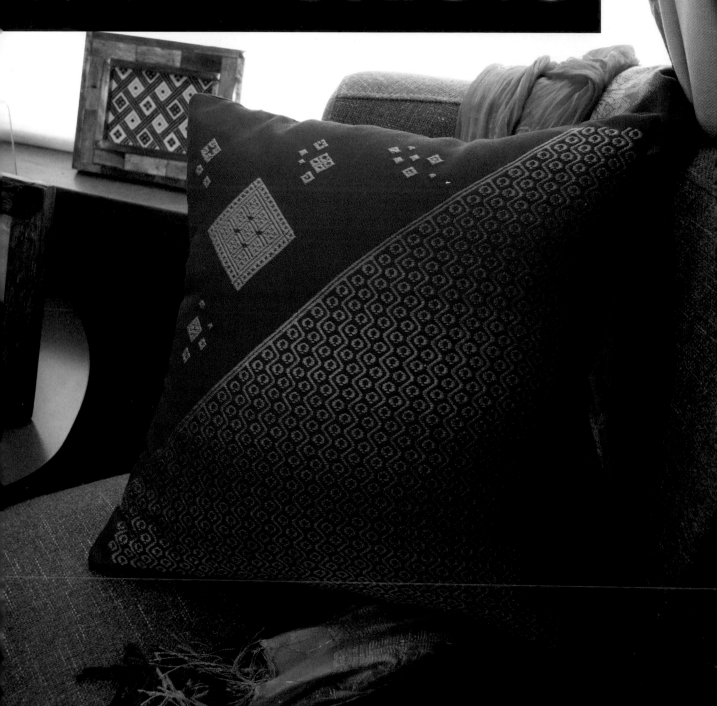

NOTES TO THE MAKER

A few notes to keep in mind as you make these projects …

• LEFT AND RIGHT

Left and right in garment patterns indicate left and right sides as worn.

• SEW/SEW

You can sew by hand or machine. We do quite a bit of both ….

• SHOPPING FOR EVENWEAVE

You can buy evenweave in precuts and yardage. Where possible, we give you yardage for larger projects. Otherwise, please purchase enough to complete your project using precuts. Hint: You can purchase evenweave directly from us at shannonandjason.com

• REINFORCEMENTS!

We love to add lightweight interfacing to the back of our finished kogin panels. This protects the back of the stitching, keeps the kogin fabric from skewing, and helps prevent the evenweave threads from slipping out of seams. Interfacing also adds a little body to the softer evenweave, making the finished pieces more durable. In garments, an interfaced kogin panel stands up nicely to being worn without warping and wrinkling as easily.

Substitutes Accepted!

We provide patterns for all of the projects. But once you have the hang of how to calculate the number of threads per inch in a particular fabric, and how to tell which stitch patterns fit the project, you should play with both fabric and stitch patterns to make truly unique creations.

To substitute motifs that cover a different number of threads or to substitute fabric with different thread counts, you must first gather some information:

• AREA NEEDED TO COVER—how much room do I have on my fabric?

20"?

5"?

• THREAD COUNT Of the evenweave fabric:

18-count?

20-count?

• NUMBER OF THREADS the motif or stitch pattern covers:

21 threads?

210 threads?

A kogin motif that covers 210 threads stitched on 20-count fabric would require 10½" of fabric space.

$$210 \div 20 = 10.5$$

That same motif stitched on 18-count fabric would require a little more than 11½" of fabric space.

$$210 \div 18 = 11.667$$

BOOKMARKS

Finished size: 4 × 10″ (10 × 25.4cm)

Bookmarks 3, 1, and 2 (left to right)

SOME OF OUR FIRST MEMORIES OF PROJECTS IN CROCHET, KNITTING, AND CROSS-STITCH ARE OF BOOKMARKS. Bookmarks are always a good early project choice because they don't require advanced concentration skills or a huge time commitment. And the finished piece is useful and personal to the maker.

Our kogin version of these practical little treasures is a satisfying make when you don't want to wait for a week (or a month) to finish a complex project. And they don't require too much concentration, so you can free up more of your mind to watch your favorite Wachowski film, or keep watch for your stop during your commute so you don't end up at the Canadian border when you are just trying to go shopping downtown ... just sayin'.

Materials

Evenweave fabric

	*Evenweave type	Thread count	Color
Bookmark 1	Davosa	18-count	Ivory
Bookmark 2	Lugana	20-count	Antique white
Bookmark 3	Davosa	18-count	White

kraft-tex Designer

Bookmark 1	Natural	Half 8½″ × 11″ sheet
Bookmark 2	Sapphire	Half 8½″ × 11″ sheet
Bookmark 3	Sapphire	Half 8½″ × 11″ sheet

Kogin thread

Aurifil cotton floss or 12-weight cotton thread in these colors:

	*Floss / 12-weight	Color 1	Color 2	Color 3	Color 4	Color 5	Color 6	Color 7
Bookmark 1	Floss	5018	1147	2908				
Bookmark 2	12-weight	1240	1243	2562				
Bookmark 3	Floss	2780	2135	2588	1243	2692	2250	2568

Fusible interfacing, like Wonder Fuse

Kogin sashiko needle and palm thimble (pages 15 16)

Sewing machine and machine thread to match fabric. We use Aurifil 50-weight thread.

Cutting

See Before You Stitch (page 30) to learn how to prepare fabric, how to cut evenweave using a thread pull, and how to overcast edges.

For each bookmark, cut the following:

EVENWEAVE

- 1 rectangle 5″ × 11″ (13 × 28cm)

KRAFT-TEX

- 1 rectangle 3″ × 9″ (7.5 × 23cm)

Fusible interfacing

- 1 rectangle 3″ × 9″ (7.5 × 23cm)

■ Construction

▌ STITCH THE KOGIN DESIGN

See Before You Stitch (page 30) to learn how to prepare the kogin thread, how to find and mark the center of the fabric, and how to begin stitching.

1. Mark the evenweave center point with contrasting thread.

2. Arrange our sample motifs to suit your taste or choose others from the Kogin-zashi Stitch Library. See Substitutes Accepted! (page 123). We used these:

- Bookmark 1: Large diamond from Tiled Modoco 8 (page 82)

- Bookmark 2: Full Pattern 10 variation, omitting the top and bottom vertical squares in each motif (page 114).

- Bookmark 3: Secondary Modoco Set 1, motif A, plus motifs A, B, and C from Modoco Set 1 (page 76, 73).

3. Stitch the motif, starting at the center and working outward in both directions. We choose to randomly assign colors to each modoco, using a single color for all the smaller side motifs.

▌ FINISHING

1. Apply fusible interfacing to the back of the finished kogin stitching, following the manufacturer's instructions.

2. Center kraft-tex on the back of the bookmark and apply to the fusible interfacing, following the manufacturer's instructions.

3. Fold under the evenweave fabric edges ¼″, and press.

4. Fold the evenweave edges over the kraft-tex, and press. Clip into place.

5. Topstitch ⅛″ from the edge in matching thread, OR follow steps 1 and 2 as directed above, then finish with a frayed edge.

3. Topstitch or hand stitch with a backstitch or overcast stitch the first 3–4 woven edge threads together to keep the edge from further unraveling.

4. Tease out threads, one at a time, from all four sides to create approximately 1″ of frayed thread.

Use your bookmarks in your favorite books … maybe in one with a Kogin Book Cover (page 139).

FRAMED ART

Finished sizes: 5″ × 7″ (13 × 18cm), 4″ × 6″ (10 × 15.25cm), 8″ × 10″ (20.5 × 25.5cm)

Framed Art 1 and 3 (left to right)

OUR WALLS ARE ADORNED WITH TREASURED QUILTS, wallhangings that are quilted, boro, and sashiko, and framed quilt blocks and sashiko and boro sample squares. Each tells a story of the hands that created them, and familiar fabrics remind us of that house dress they used to wear, or that work shirt put to better use after one-too-many patches and repairs. To us, these are all works of art.

Two of our favorite installations are a set of unfinished quilt blocks from Jason's family and a quilt made by Shannon's grandmother. Looking at their hand stitches and remembering the best parts of those folx, even just for a minute in passing, gives us a sense of history and grounding for our current work.

Here we follow in that tradition of creating small framed pieces of fiber art that are as much about the overall visual appeal as they are about reminding us of the long tradition of fiber artists who came before us. Who knows, maybe someday someone will hang your work on their walls and feel that sense of connection and deeper time when they look at your stitches.

Materials

*Evenweave fabric: See Cutting (page 33) for cut sizes and buy precuts large enough to make your art choices.

	Evenweave type	Thread count	Color
Framed Art 1	Lugana	20-count	Antique white
Framed Art 2	Lugana	20-count	Hand-dyed, indigo
Framed Art 3	Linen Aida	18-count	Natural
Framed Art 4	Lugana	20-count	Off white
Framed Art 5	Lugana	20-count	White

Kogin thread: Aurifil cotton floss or 12-weight cotton thread in these colors:

	Floss/12wt	Color 1	Color 2	Color 3
Framed Art 1	Floss	5018	2882	1147
Framed Art 2	12wt	2311		
Framed Art 3	Floss	2740	2815	
Framed Art 4	Floss	2395		
Framed Art 5	Floss	2545	1243	

Kogin sashiko needle and palm thimble (pages 15 16)

Cutting

See Before You Stitch (page 30) to learn how to prepare fabric, how to cut evenweave using a thread pull, and how to overcast edges.

FRAMED ART 1 OR 3

- 1 rectangle 6″ × 8″ (15 × 20cm)

FRAMED ART 2 OR 5

- 1 rectangle 10″ × 12″ (25.4 × 30.5cm)

FRAMED ART 4

- 1 rectangle 7″ × 9″ (18 × 23cm)

◼ Construction

▌ STITCH THE KOGIN DESIGN

See Before You Stitch (page 30) to learn how to prepare the kogin thread, how to find and mark the center of the fabric, and how to begin stitching.

1. Mark the evenweave center point with contrasting thread.

2. Arrange our sample motifs to suit your taste or choose others from the Kogin-zashi Stitch Library. See Substitutes Accepted! (page 123). We used these:

- Framed Art 1: Full Pattern 1 (page 106) stitched on 4″ × 6″ (10 × 15.25cm) of 20-count fabric

- Framed Art 2: Full Pattern 5 (page 110) stitched on 8″ × 10″ (20.5 × 25.5cm) of 20-count fabric

- Framed Art 3: Full Pattern 2 (page 107) stitched on 4″ × 6″ (10 × 15.25cm) of 18-count fabric

- Framed Art 4: Full Pattern 3 (page 108) stitched on 5″ × 7″ (13 × 18cm) of 20-count fabric

- Framed Art 5: Full Pattern 4 (page 109) stitched on 8″ × 10″ (20.5 × 25.5cm) of 18-count fabric

If you are using your own kogin motifs, measure the visible space in your frame and use a water-soluble pen to mark the edges.

3. Stitch the motif, starting at the center and working outward in both directions. If you are using your own pattern or random modoco, stitch to the marked edge.

▌ FINISHING

1. For framed stitchery, cut a piece of cardboard the size of your photo window minus ¼″ (6mm) on all sides.

2. Wrap your artwork around the cardboard and insert it into the frame. For added security, use double-sided or low-tac tape to hold the evenweave in place.

Or for a fully open frame …

1. Topstitch or hand stitch with a backstitch or overcast stitch the first 3–4 woven edge threads together to keep the edge from further unraveling (page 63).

2. Tease out threads, one at a time, from all sides to give 1″ (2.5cm) of frayed thread.

3. Insert your artwork into the frame.

Framed Art 5 (top), 2 (bottom left), and 4 (bottom right)

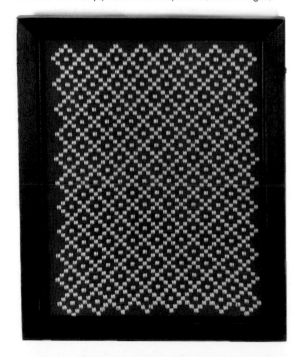

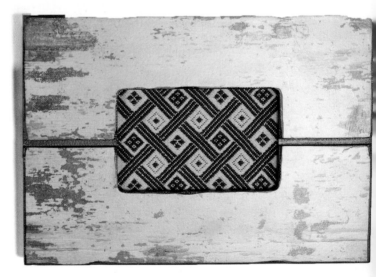

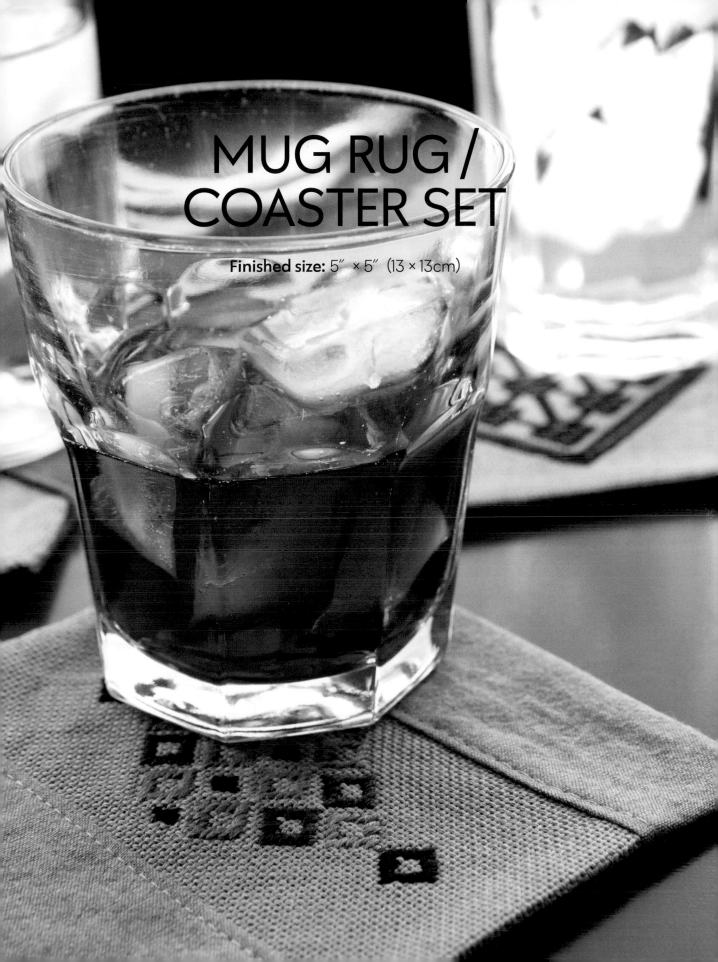

MUG RUG / COASTER SET

Finished size: 5″ × 5″ (13 × 13cm)

THIS COASTER AND MUG RUG SET IS DESIGNED TO COORDINATE WITH THE PLACEMATS … but don't let that stop you from expressing your own creativity with colors and fabric types. These are FAB projects for using up evenweave scraps and small treasures of fabric. Give them as a housewarming gift or just keep them for yourself … probably that last one.

Materials

Evenweave fabric: ¼ yard (23cm). We used 20-count Lugana we hand-dyed in Goldenrod.

Denim or other fabric: ¼ yard (23cm) for the border and backing. We used scraps of Robert Kaufman denim from a previous project as well as salvaged denim from our own collection (our old clothes).

Scrap fabric for piecing fronts. Again … we dug into our denim scraps.

Kogin thread: Aurifil cotton floss or 12-weight cotton thread in these colors:

	*Floss/12wt	Color 1	Color 2	Color 3
Coaster 1	Floss	2355	2320	2315
Coaster 2	12wt	5022		
Coaster 3	Floss	2785	2735	2720
Coaster 4	Floss	1240		
Coaster 5	12wt	1240		
Coaster 6	12wt	2745		

Hand- or machine-sewing thread: We use Aurifil 50-weight.

Kogin sashiko needle and palm thimble

Hand sewing needle (optional)

Sewing machine (optional)

Cutting

See Before You Stitch (page 30) to learn how to prepare fabric, how to cut evenweave using a thread pull, and how to overcast edges.

Cut fabric as shown on the cutting schematic (below).

Construction

All seams are sewn at ¼″ (6mm).

STITCH THE KOGIN PANELS

See Before You Stitch (page 30) to learn how to prepare the kogin thread, how to find and mark the center of the fabric, and how to begin stitching.

1. Mark the evenweave center point with contrasting thread.

2. Use our sample motifs or choose your own from the Kogin-zashi Stitch Library. See Substitutes Accepted! (page 123).

- Coaster 1: Tiled Modoco Set 1, motif D (page 78)
- Coaster 2: Tiled Modoco 12 (page 84)
- Coaster 3: Tiled Modoco 8 (page 82)
- Coaster 4: Standalone Combination 1 (page 91)
- Coaster 5: Tiled Modoco 11 (page 84)
- Coaster 6: Tiled Modoco 7 (page 82)

3. Stitch the motifs, starting at the center and working outward in both directions.

Clockwise from top left: Coaster 6, Coaster 5, Coaster 1, Coaster 3, Coaster 2, and Coaster 4

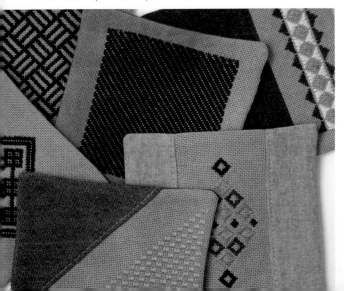

ASSEMBLE THE COASTER FRONTS

1. Referring to the assembly diagram, assemble the coaster fronts.

2. Square up the pieced fronts to 6″ × 6″ (15 × 15cm), using a square quilting ruler or template.

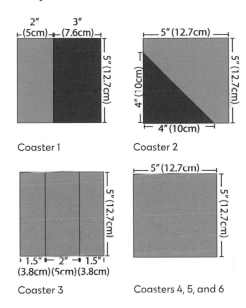

Coaster 1　　　Coaster 2

Coaster 3　　　Coasters 4, 5, and 6

FINISHING

1. With right sides facing, place the finished fronts and backing fabric together.

2. Hand or machine sew around the edges, leaving a 3″ (8cm) opening for turning.

3. Trim the corners as shown in Perfectly Precise Points (page 138).

4. Turn the coaster right side out through the opening.

5. Press flat and as shown in Turn and Press (page 138).

PLACEMATS

WHEN WE SIT DOWN FOR A MEAL, WE ARE UNITED BY THE COMMON RELATIONSHIP THAT BRINGS US TOGETHER TO SHARE A MEAL. We share food, engage in conversation, reflect on the day, and build camaraderie should we have someone to share that meal with. Making mealtime more special, by including a handmade touch to the setting, adds an element of warmth and completeness that transcends the actual food. Choose colors that accent your decor and even make multiple sets for different seasons and moods.

Materials

Evenweave fabric: 1½ yards (1.3m) Lugana 20-count or pieces to fit measurements in the cutting schematic

Denim or other fabric:½ yards (1.3m). We used Robert Kaufman denim and salvaged denim from our collection (our old clothes).

Kogin thread: Aurifil cotton floss or 12-weight cotton thread in these colors:

	*Floss/12wt	Color 1	Color 2	Color 3
Placemat 1	Floss	2355	2320	2315
Placemat 2	12wt	5022		
Placemat 3	Floss	2785	2735	2720
Placemat 4	Floss	1240		
Placemat 5	12wt	1240		
Placemat 6	12wt	2745		

Hand- or machine-sewing thread: We use Aurifil 50-weight thread.

Kogin needle and palm thimble

Hand-sewing needle (optional)

Sewing machine (optional)

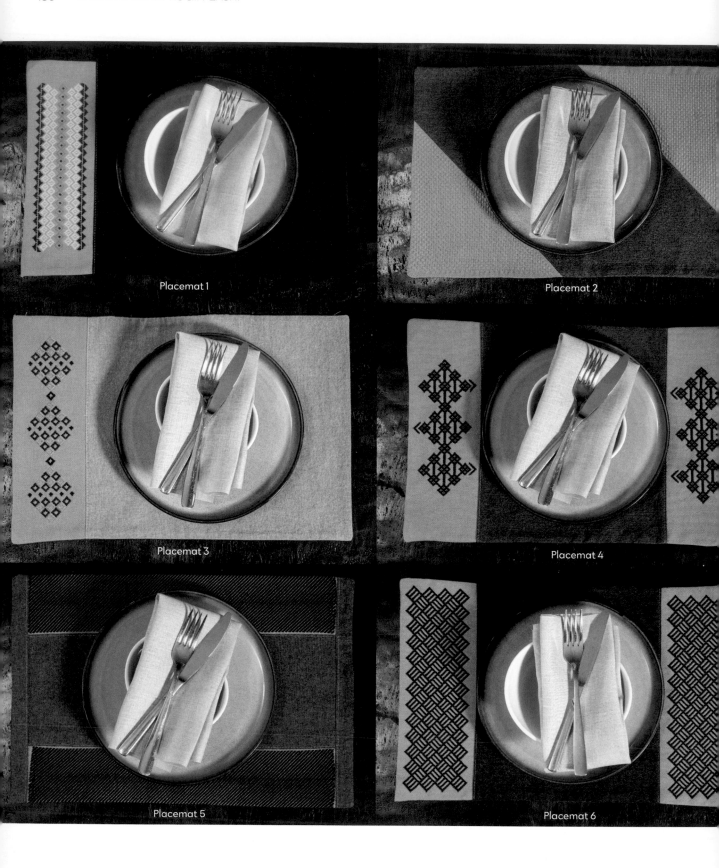

Placemat 1

Placemat 2

Placemat 3

Placemat 4

Placemat 5

Placemat 6

Cutting

See Before You Stitch (page 30) to learn how to prepare fabric, how to cut evenweave using a thread pull, and how to overcast edges.

Cut evenweave and backing fabric to dimensions shown in the cutting diagram.

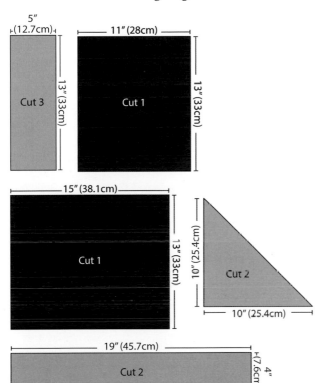

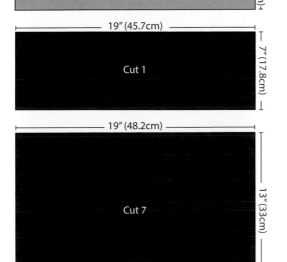

■ Construction

All seams are sewn at ¼″ (6.5mm). All topstitching is ⅛″ (3.25mm).

▌ STITCH THE KOGIN DESIGNS

See Before You Stitch (page 30) to learn how to prepare the kogin thread, how to find and mark the center of the fabric, and how to begin stitching.

1. Mark the evenweave center point with contrasting thread.

2. Use our sample motifs or choose your own from the Kogin-zashi Stitch Library. **See** Substitutes Accepted! (page 123).

- Placemat 1: Tiled Modoco Set 1, motif D variation (page 78)

- Placemat 2: Tiled Modoco 12 (page 84)

- Placemat 3: Tiled Modoco 8 (page 82)

- Placemat 4: Standalone Combination 1 (page 91)

- Placemat 5: Tiled Modoco 11 (page 84)

- Placemat 6: Tiled Modoco 7 (page 82)

3. Stitch the motif, starting at the center and working outward in both directions.

▌ ASSEMBLE THE FRONT PANELS

1. Piece together the top panels to the sizes shown in the assembly diagram.

2. Square up the fabric to 19″ × 13″ (48 × 33cm) using a quilting ruler or template.

3. Press the seams away from the evenweave.

4. Topstitch about ⅛″ (3.25mm) by hand or machine around the denim edges to fell the seams.

We used a contrasting color of Aurifil 50-weight thread to emphasize the topstitching.

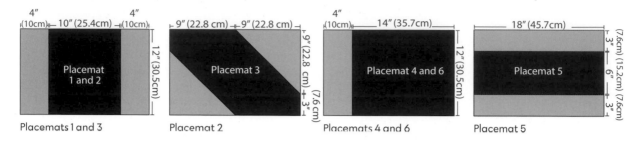

Placemats 1 and 3 Placemat 2 Placemats 4 and 6 Placemat 5

▌ FINISHING

1. With right sides facing, place the finished fronts and backing fabric together.

2. Hand or machine sew ½″ (13mm) around the edges, leaving a 3″ (8cm) opening for turning.

3. Trim the corners close to, but not through, the sewn seam.

PERFECTLY PRECISE POINTS

Before turning your work right side out, trim corners close to *but not through* the sewn seam. This will remove most of the bulk, creating a more precise point once the work is turned.

4. Turn the placemat right side out through the opening.

5. Press flat, being sure to fold the edges of the opening to the inside.

6. Hand stitch the opening closed using the ladder stitch (page 62).

TURN AND PRESS

While pressing your turned edges, press the edges of the opening to the inside of your work to make stitching the opening closed easier.

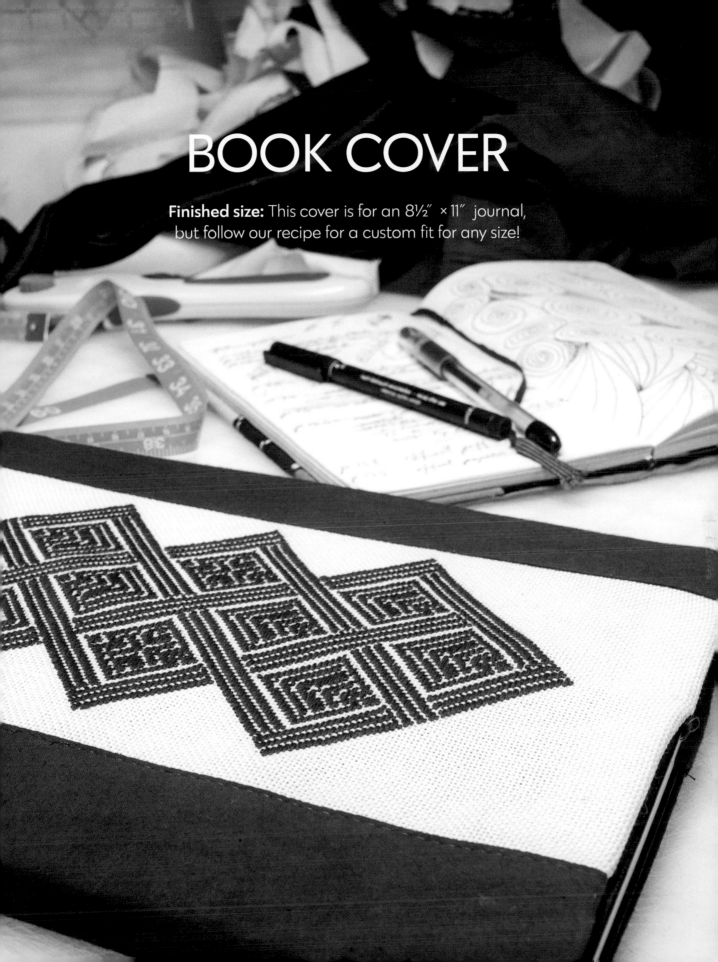

BOOK COVER

Finished size: This cover is for an 8½″ × 11″ journal, but follow our recipe for a custom fit for any size!

WHETHER YOU ARE COVERING A FAVORITE JOURNAL that holds your innermost thoughts, a precious album of photo memories, or a well-loved volume that needs a little shoring up from repeated use, these book covers are functional, feel great in your hand while holding your favorite tomes, and can even add privacy when you are indulging in that racy novella that it's just not anyone else on the bus's business.

For this project, we give you a "recipe" for creating a custom-sized book cover. All it takes is three measurements and a little bit of elementary school math, plug in the numbers, and get stitching to make a cover to fit books of any size.

These covers make great gifts to go with Framed Art (page 127), filled with pictures of friends and family ... just a thought.

Materials

Cover fabric: ½ yard (.45m) Cherrywood Hand Dyed Fabric in 1250 Fuchsia. *See Fabric Amount note.*

Evenweave fabric: Lugana 20-count in ivory 6″ × 12″ (15.2 × 30.5cm) for the motif we used.

Kogin thread: Aurifil 12-weight, color 1100 Red Plum

Woven fabric: ½ yard (.45m) Cherrywood Hand Dyed Fabric in 1250 Fuchsia

Kogin sashiko needle and palm thimble (pages 15-16)

Sewing machine and machine thread to match fabric

Note: Fabric Amount
The amount of fabric needed will vary based on the size of the book you are covering. For most books, a fat quarter will suffice. For large books, albums, and binders, you will need a bit more. Follow our recipe to measure, then, based on those measurements, use your best judgment to purchase enough fabric to complete your project.

Cutting

See Before You Stitch (page 30) to learn how to prepare fabric, how to cut evenweave using a thread pull, and how to overcast edges.

Note
Measure and cut based on the Recipe for Cutting Your Book Cover Fabric below. Overcast the edges before you wash or stitch the evenweave.

Recipe for Cutting Your Book Cover Fabric

TAKE MEASUREMENTS

With a soft measuring tape, take the following measurements:

- Measurement **A**: With the book closed, take the wrapped measurement of *both covers across the spine*. This is the measurement from the open edge of one side, across that side, around the spine, and across the opposite side to the open edge of the opposite side.

- Measurement **B**: Height of one cover

- Measurement **C**: Width of one cover

Measurement guide

Measurement for the Total Cover

1. Add the width of one cover to the wrapped measurement.

A + C

2. Add 2″ (5cm) to the height measurement.

B + 2″

Example measurements from our sample

Our book has the following measurements:

A = 11″ (28cm)

B = 8¼″ (21cm)

C = 5⅛″ (3mm)

A + C = 16⅛″ (41cm)

B + 2″ = 10¼″ (26cm)

Based on these measurements, our final book cover fabric was a rectangle 16⅛″ × 10¼″ (41 × 26cm).

Note
Important: Every book is a little different—you need to take your own measurements.

Measurement for the Kogin Insert

1. Use ½ of **C** *plus* 1″ (for the seam allowance) for the width.

For the height, use the same measurement as the book cover, **B + 2″**.

Construction

All seams are sewn at ½″ (13mm).

STITCH THE KOGIN PANEL

See Before You Stitch (page 30) to learn how to prepare the kogin thread, how to find and mark the center of the fabric, and how to begin stitching.

1. Mark the center point of the evenweave fabric with contrasting thread.

2. Use our sample motif or, if your book to cover is larger or smaller than ours, choose your own from the Kogin-zashi Stitch Library. See Substitutes Accepted! (page 123).

• Full Pattern 6 (page 111)

3. Stitch the motif, starting at the center and working outward in both directions.

PIECE THE BOOK COVER TOGETHER

1. With the right sides facing, attach the kogin insert to the other cover pieces.

2. Press seams flat to one side, away from the evenweave.

3. Topstitch on the non-evenweave fabric ⅛″ from the seam to fell and reinforce the seam and give a polished finish.

ONE LAST BIT OF MATH …

1. With right sides facing up, fold both short sides inward ½ the width of one cover, minus ⅛″ (3mm).

$(C \div 2) - \tfrac{1}{8}″$ (3mm).

> **Note**
> *We subtract the ⅛″ (3mm) because kogin stitching will tend to pull in the fabric a bit.*

2. Press along the fold to form a crease.

SEW FOLDED EDGE

1. Mark ¾″ (2cm) from the top and bottom edges on the folded fabric (four marks).

2. Sew the folds along the marked top and bottom edges (four seams sewn).

FINISHING

1. Turn the cover right side out.

2. Press the seams to tidy up the edges as needed.

3. Insert the book.

TAKE–ALONG TOTE

Finished size: 14″ × 14″ (35½ × 35½cm)

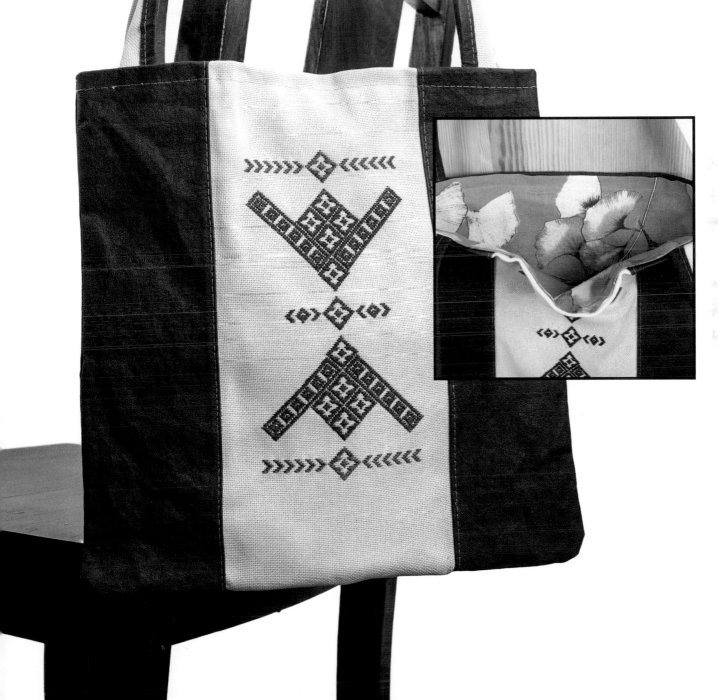

THE UBIQUITOUS TOTE BAG HAS MORE THAN EARNED ITS PLACE BY OUR SIDES FOR CARRYING CONTAINERS OF LEFTOVERS AND WRAPPED SANDWICHES to our favorite lunch spots and for transporting all of the necessary supplies for a day of shopping downtown. And how many do you have in your trunk and on the floor of your back seat right now to avoid those horrid plastic bags in the market? Tote bags are versatile in both use and appearance, and ours is lined for a little added flair. Pick your favorite fabrics, stitch up a gorgeous bit of kogin on some evenweave, and you'll have a stylish new accessory to accompany you just about everywhere.

Materials

20-count evenweave fabric: ½ yard (46cm) for the kogin panel and handles. We used Lugana 20-count in color Ivory.

Light cotton canvas or muslin: ½ yard (46cm) for the outer fabric

Lining fabric: ½ yard (46cm)

Outside bag fabric and handle accents: We used kraft-tex Designer, one roll 18½″ × 28½″

Kogin thread: Aurifil 12-weight cotton thread in these colors:

Color A	Color B	Color C
2395	2355	2240

Kogin sashiko needle and palm thimble (pages 15–16)

Sewing machine and machine thread to match fabric: We use Aurifil 50-weight thread.

Hot glue: We used Gorilla Glue brand hot glue.

Cutting

See Before You Stitch (page 30) to learn how to prepare fabric, how to cut evenweave using a thread pull, and how to overcast edges.

Cut fabric as shown on the cutting schematic (below).

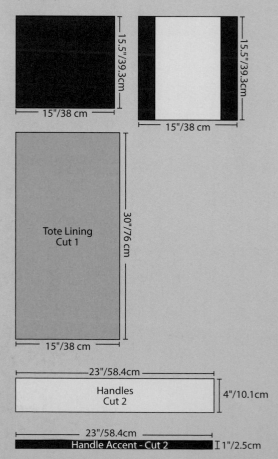

Construction

Seam allowances are ½″ (1.5cm) unless otherwise noted.

STITCH THE KOGIN PANEL

See Before You Stitch (page 30) to learn how to prepare the kogin thread, how to find and mark the center of the fabric, and how to begin stitching.

1. Mark the evenweave center point with contrasting thread.

2. Use Full Pattern 7, as we did, or choose your own from the Kogin-zashi Stitch Library. See Substitutes Accepted! (page 127).

3. Stitch the motif, starting at the center and working outward in both directions.

4. Trim the finished kogin panel to 15″ × 30″ (38 × 76cm).

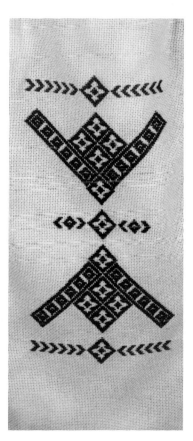

CONSTRUCT THE HANDLES

1. With the wrong side facing up, fold the handle in half down the length, and press.

Fold.

2. Finger press open, wrong side facing up, and fold the left and right sides in towards the centerline. Press the sides, then refold in half along the center and press.

Fold.

3. Using a sewing machine, close the long side of the handle by sewing an ⅛″ (3mm) seam.

4. Sew a second line of stitches along the folded edge to match the first ⅛″ (3mm) seam.

5. Fold the kraft-tex accent in half lengthwise, and press.

6. Clip the kraft-tex accent piece to each handle and topstitch ⅛″ (3mm) from the cut edge through all the layers.

▌ ASSEMBLE THE TOTE

Assemble the Outer Body

1. With right sides facing, attach the right and left sides of outer body side 1 to the trimmed and overcast kogin panel.

2. With right sides facing, sew outer body side 1 and outer body side 2 together.

Square Up the Tote

Trim any overhanging edges to square up the sides of the tote.

Sew Side Seams of Body and Lining

1. Fold the outer body in half with right sides facing together, and sew the side seams.

2. Pin the interior pocket to the right side of the lining fabric, as shown in the assembly diagram, and sew it into place.

3. Fold the lining in half with the right sides facing together and sew the side seams.

4. Turn the lining wrong side out.

Assemble the Bag

1. Fold the tops of the outer bag and lining ½″ (13mm) and sew around approximately ⅜″ (9mm) from the folded edge.

2. Insert the lining into the outer bag with the wrong sides facing each other.

3. Measure 3½″ (9cm) from both the right and left edges on the wrong side of the tote, and make a mark on each side for the handle placement.

4. Insert the handles between the lining and outer bag fabric so that two edges of one handle face the front and two edges of the other face the back of the bag.

5. Pin/Wonder clip the center of each strap at the marked line.

6. Fire up the hot glue gun! Generously glue around the inside top edges of bags being sure to glue handles securely in place. Wonder Clip the glued edges and let glue set according to the manufacturer's instructions.

▌ *Note*
We used hot glue because of the thickness of the folded kraft-tex in combination with the canvas lining fabric. We have done this with quite a few totes and they are tough and sturdy pieces that we use regularly.

Don't stop now! Customize your totes to be smaller or larger by adjusting the size of the base fabric. Add more interior pockets or add an exterior pocket. You can even customize those free totes you pick up at markets and events by adding kogin panels and custom straps to your heart's content so that all your totes become functional art.

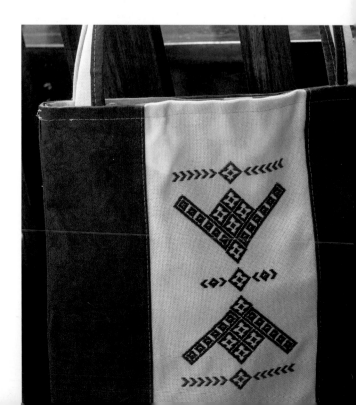

LOOKIN' AT PILLOW

Finished size: 20″ × 20″ (50.8cm × 50.8cm)

THERE ARE BATH TOWELS, KITCHEN TOWELS, AND PILLOWS IN OUR PANTRY AND CEDAR CHEST that are lookin' at towels and lookin' at pillows. These are used only on the most special of occasions and, even then, the towels aren't actually used for drying anything and the pillows will never be sat upon, nor will a head ever lay upon them. They are for lookin' at. Only.

While we do have dozens of well-used throw pillows throughout our house, we also have a few made from special or vintage fabrics which are, yes, just for lookin' at. They bring joy by merely existing in the room. When we first designed this pillow, we couldn't wait to use it in our living room but, even before the stitching was finished, we looked at one another and agreed this was, indeed, a lookin' at pillow.

Materials

Evenweave fabric: 1 square 20″ × 20″ (51 × 51cm). Sample uses Lugana 20-count in Christmas Red.

Kogin thread: Aurifil 12-weight cotton thread in these colors:

Color A	Color B	Color C
2395	2235	1133

Cotton or other fabric: 1 square 19″ × 19″ (48.25 × 48.25cm) for the pillow back.

Sample uses Robert Kaufman Brussels Washer Linen in Poppy

1 pillow form: 20″ × 20″ (50 × 50cm)

Hand- or machine-sewing thread: We use Aurifil 50-weight thread.

Kogin sashiko needle and palm thimble (pages 15–16)

Hand sewing needle (optional)

Sewing machine (optional)

Cutting

See Before You Stitch (page 30) to learn how to prepare fabric, how to cut evenweave using a thread pull, and how to overcast edges.

Cut fabric as shown on the cutting schematic (below).

Construction

All seams are sewn at ½″ (13mm).

STITCH THE KOGIN DESIGN

See Before You Stitch (page 30) to learn how to prepare the kogin thread, how to find and mark the center of the fabric, and how to begin stitching.

1. Mark the center point of the evenweave with contrasting thread.

2. Use our sample motif or choose your own from the Kogin-zashi Stitch Library. See Substitutes Accepted! (page 123).

We used Lookin' at Pillow full pattern (page 86–89).

See Breaking It Down (page 44) for how to use the Lookin' at Pillow repeat charts (pages 86–89) to stitch the overall pattern.

3. Stitch the motif, starting at the center and working outward in both directions.

4. Square up the stitched fabric to 19″ × 19″ (48.2cm × 48.2cm) with a quilting ruler or template.

ASSEMBLE THE PILLOW

1. With right sides facing, place the finished stitched front and backing fabric together.

2. Hand or machine sew around edges, leaving about a 4″ (10cm) opening large for turning and inserting the pillow form.

3. Trim the corners close to, but not through, the sewn seam.

4. Turn the pillow right side out through the opening.

5. Press the seams flat, being sure to fold the opening edges to the inside.

6. Hand stitch the opening closed using a ladder or slip stitch (page 62).

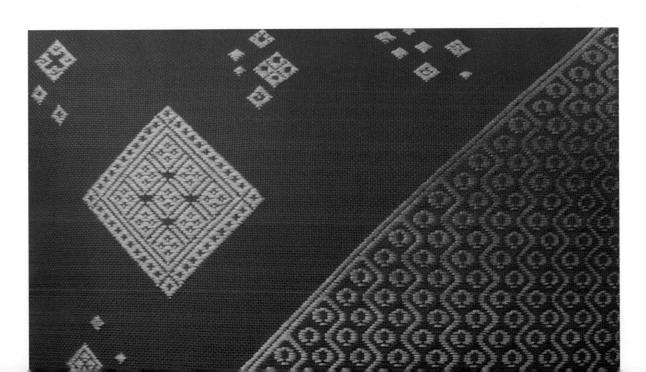

MODOCO WALLHANGING

Finished wallhanging: 46″ × 36″ (117 × 92cm)

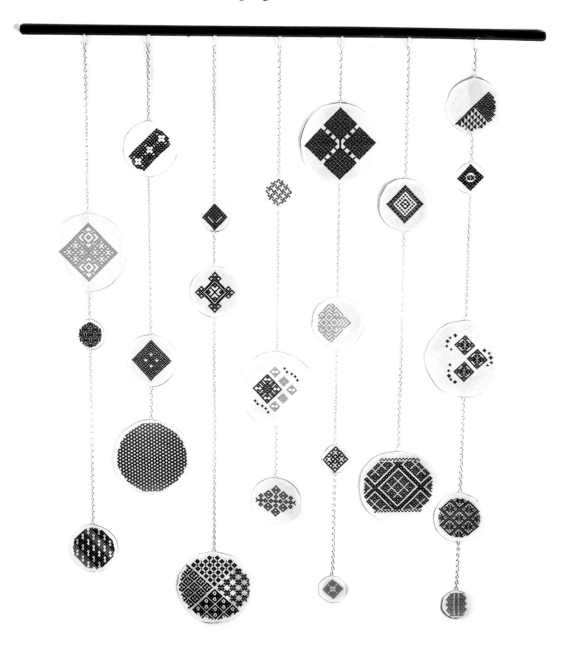

WE'VE MENTIONED THAT THERE IS HARDLY A WALL IN OUR HOME THAT ISN'T DECORATED WITH FIBER ART PIECES and, because Jason pulls double duty as a photographer, gorgeous photos eh-ver-eey-where. For this wallhanging, we wanted to embrace our creative chaos and make something that is truly art for the sake of something beautiful to look at. We were inspired by the style of mid-century modern abstract art and created an arrangement of some of our favorite kogin motifs. Feel free to experiment with layout and presentation to create a one-of-a-kind piece of art for your space.

Materials

Evenweave fabric, 20-count: ½ yard (46cm) for the kogin. We used 20-count Lugana in antique white.

Backing fabric: ½ yard (46cm). Sample uses Cherrywood Hand Dyed Fabric in color Red Earth # 0200

Iron-on double-sided stabilizer: ½ yard (46cm)

String, twine, light rope, or light chain: 13' (4m)

Needle-nose pliers

Cup hooks: 7

Brad nails: 5 for mounting

Hanging pole: Approximately 40" (102cm)

Kogin sashiko needle and palm thimble (pages 15–16)

Hand sewing needle and thread

Sewing machine and machine thread to match fabric. We use Aurifil 50-weight thread.

Kogin thread: Aurifil cotton floss or 12-weight cotton thread in these colors:

	Floss/12wt	Color A	Color B	Color C
Circle 1	Floss	2145		
Circle 2	Floss	2250		
Circle 3	Floss	2785	2780	2815
Circle 4	Floss	2780		
Circle 5	Floss	2568		
Circle 6	12wt	2270	2250	2260
Circle 7	Floss	2250		
Circle 8	Floss	2780		
Circle 9	Floss	1240	2545	
Circle 10	12wt	1243		
Circle 11	Floss	2785	2780	2815
Circle 12	Floss	2245		
Circle 13	Floss	2250		
Circle 14	Floss	2145		
Circle 15	Floss	2780		
Circle 16	Floss	2145		
Circle 17	Floss	2568		
Circle 18	Floss	2735	2785	
Circle 19	Floss	2568		
Circle 20	Floss	2780		
Circle 21	Floss	2568		
Circle 22	12wt	2250	2270	2245
Circle 23	Floss	2145		

Cutting

See Before You Stitch (page 30) to learn how to prepare fabric, how to cut evenweave using a thread pull, and how to overcast edges.

EVENWEAVE FABRIC

Overcast the edges to prevent fraying.

- 7 squares 8″ × 8″ (20.5 × 20.5cm)
- 9 squares 6″ × 6″ (15.25 × 15.25cm)
- 7 squares 4″ × 4″ (10.25 × 10.25cm)

BACKING FABRIC

- 7 circles 7″ (18cm) in diameter
- 9 circles 5″ (13cm) in diameter
- 7 circles 3″ (8cm) in diameter

STABILIZER

- 7 circles 6″ (15cm) in diameter
- 9 circles 4″ (10cm) in diameter
- 7 circles 2″ (5cm) in diameter

■ Construction

Seam allowances are ½″ (1.5cm) unless otherwise noted.

▌ STITCH THE KOGIN CIRCLES

See Before You Stitch (page 30) to learn how to prepare the kogin thread, how to find and mark the center of the fabric, and how to begin stitching.

1. If necessary for your chosen modoco, use a water-soluble pen to draw a circle to the *finished* circular dimensions on the square. Do not cut a circle until you have finished the kogin stitching.

2. Mark the evenweave center point with contrasting thread.

3. Use our sample motifs or choose your own from the Kogin-zashi Stitch Library. See Substitutes Accepted! (page 123). Sample uses:

▌ 7 MOTIFS 6″ (15CM) IN DIAMETER

Stand-Alone Combination 22 (page 99)

Stand-Alone Combination 23 (page 100)

Stand-Alone Combination 24 (page 101)

Stand-Alone Combination 25 (page 102)

Stand-Alone Combination 26 (page 102)

Stand-Alone Combination 27 (page 103)

Stand-Alone Combination 29 (page 105)

▌ 9 MOTIFS 4″ (10CM) IN DIAMETER

Stand-Alone Combination 13 (page 95)

Stand-Alone Combination 14 (page 95)

Stand-Alone Combination 15 (page 96)

Stand-Alone Combination 17 (page 97)

Stand-Alone Combination 18 (page 97)

Stand-Alone Combination 19 (page 98)

Stand-Alone Combination 20 (page 98)

Stand-Alone Combination 21 (page 99)

Stand-Alone Combination 16 (page 96)

▌ 7 MOTIFS 2″ (5CM) IN DIAMETER

Stand-Alone Combination 6 (page 92)

Stand-Alone Combination 7 (page 92)

Stand-Alone Combination 8 (page 92)

Stand-Alone Combination 11 (page 94)

Stand-Alone Combination 12 (page 94)

Secondary Modoco Set 4, motif A (page 77)

Secondary Modoco Set 4, motif B (page 77)

4. Stitch each motif, starting at the center and working outward in both directions.

▌ TRIM THE MODOCO TO CIRCLES

1. Use a template to mark your fabric with circles in the following measurements, which are 1″ (2.5cm) larger than the finished size.

- 7 circles 7″ (18cm) in diameter
- 9 circles 5″ (13cm) in diameter
- 7 circles 3″ (8cm) in diameter

▌ COMPLETE THE CIRCLES

1. Centered over the motif, iron double-sided stabilizer to the wrong side of each kogin circle. Remove the paper backing.

2. Cut a 2″ slit in the center of each backing fabric.

3. Place a stabilized kogin circle and backing circle together, right sides facing. Sew around the circle using a ½″ (13mm) seam allowance.

> ### Note: Make It Easy on Yourself
> *Sewing circles by sight can be tricky. Make it easier on yourself and use a sewing machine foot made specifically for sewing circles, look up a tutorial for using a thumbtack to hold the center of the fabric (many can be found online), or use a water-soluble marker to draw a line where to sew and TAKE YOUR TIME.*

4. Snip the edges of each circle to just shy of the sewn line (allows the edges to lay flatter inside the finished disc) or trim around the edges with pinking shears.

5. Turn the circle right side out through the slit in the backing fabric. Run a turner or chopstick around the inside of the seams to smooth it out.

6. Press to finish.

▌ ASSEMBLE THE WALLHANGING

1. Following the assembly schematic, attach seven cup screws to a dowel, curtain rod, or other piece of wood 40″ (101cm) long. We used ¼ circular trim and attached the cup hooks to one of the flat sides.

2. Attach cup screws to the rod 5″ (12cm) apart.

3. Mount with picture hangers or brad nails attached to the main support rod.

4. Cut string, twine, rope, or chain (connector) to the lengths shown in the cutting schematic.

5. Arrange the circles and connectors according to the layout in the cutting schematic.

6. Hand stitch each circle to the connectors until all rows are assembled.

7. Attach the top of each row to a cup screw.

Assembly

12.5"
31.7cm

5.5"
14cm

12"
30.5cm

9.5"
24.1cm

3.5"
8.9cm

9.5"
24.1cm

2"
5cm

19

2"
5cm

13

4

1

7

20

2"
5cm

8.5"
21.6cm

9.5"
24.1cm

12.5"
31.7cm

2.5"
6.3cm

17

10

2"
5cm

11"
27.9cm

8

14

2

5

21

14"
35.5cm

2.5"
6.3cm

11

7.5"
19cm

17.5"
44.5cm

6

19.5"
49.5cm

4"
10.2cm

15

18

7.5"
19cm

12

8.5"
21.6cm

22

3

9

16

4"
10.2cm

23

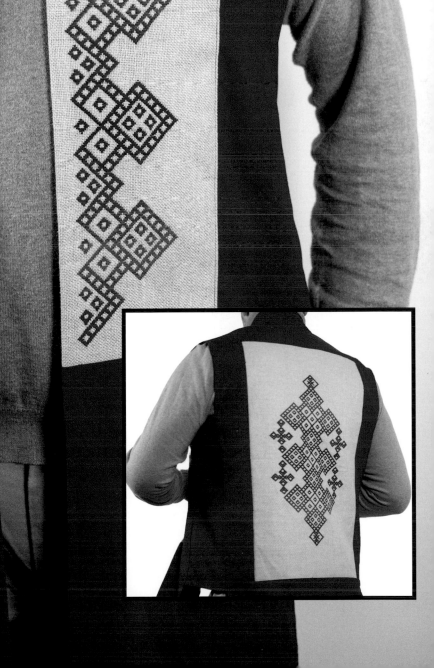

SASHIKO VEST #2

YES, THERE IS A SASHIKO VEST #1.

Yes, we are horrible at naming patterns.

Nevertheless … this vest design, the second in a series, is inspired by a traditional Japanese garment meant to be worn over other garments. We have made this same silhouette dozens of times but here we've added an extra wide collar for added drama. Also for this version, we added subtle shaping to the back of the neck and the shoulders for a more custom fit. Because of the rectangular pieces of the base pattern, you can alter the length of the front and back panels, change the armhole depth, lengthen the side panels, or change the width of the collar for an even more customized garment that fits your body and your style.

Size	S	M	L	XL	2X	3X	4X	5X
Measured bust: inches (cm)	32 (81.3)	36 (91.4)	40 (101.6)	44 (111.8)	48 (121.9)	52 (132.1)	56 (142.2)	60 (152.4)
Finished bust: inches (cm)	34 (86.4)	38 (96.5)	42 (106.7)	46 (116.8)	50 (127.0)	54 (137.2)	58 (147.3)	62 (157.5)

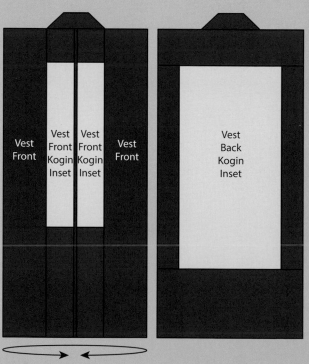

Materials

18-count evenweave fabric: 1 yard (1m) evenweave. We used 18-count Cork Linen in color Natural.

Linen or other fabric: 2 (2, 2, 2, 3, 3, 3, 3) yards (2 (2, 2, 2, 3, 3, 3, 3) m. We used Robert Kaufman Brussels Washer Linen in Poppy.

Kogin thread: Aurifil 12-weight cotton thread in these colors:

Color A	Color B	Color C
2260	2250	2255

Kogin sashiko needle and thimble (pages 15–16)

Sewing machine and machine thread: We used Aurifil 50-weight thread in 2265, Lobster Red, to match the jacket fabric.

PATTERN NOTES

- It may be beneficial to highlight your selected size throughout the pattern before measuring and cutting.

- All seams are ½″ (13mm) unless otherwise noted.

- Seams are included in the cutting measurements.

- Complete the kogin stitching on individual components before sewing/overlocking the garment together.

- This jacket is not lined. To keep internal seams from fraying, we recommend surging/overlocking the body pieces using a 3-needle overlock or a machine overcast/zigzag stitch along the edge. If you are hand sewing, overcast the raw edges to prevent fraying. You can also use an encased seam, such as a French seam. See Modified French Seam (page 168).

- When sewing evenweave to other fabrics, press the seam allowance away from the evenweave whenever possible.

- Once seams are pressed open or to the side, you can topstitch or use a prick stitch to fell the seams to secure them further.

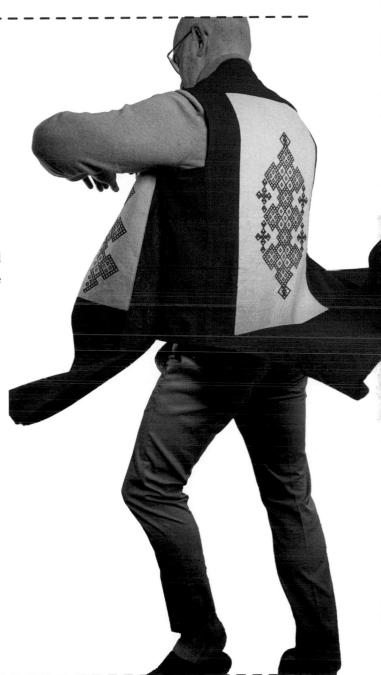

Cutting

See Before You Stitch (page 30) to learn how to prepare fabric, how to cut evenweave using a thread pull, and how to overcast edges.

Cut components according to the sizes in the cutting chart (right) and overcast all edges to reduce fraying (page 36).

Piece	Quantity	S	M	
Cut from evenweave:				
Kogin back	Cut 1.	13" × 22" (33 × 55.8cm)	13" × 22" (33 × 55.8cm)	
Kogin collar insert	Cut 2.	6" × 15" (15 × 38cm)	6" × 15" (15 × 38cm)	
Cut from vest fabric:				
Vest back top	Cut 1.	15½" × 5" (39 × 13cm)	16¼" × 5" (41 × 13cm)	
Vest back bottom panel	Cut 1.	15½" × 19" (39 × 48cm)	16¼" × 19½" (41 × 50cm)	
Back sides	Cut 2.	2¼" × 22" (6 × 56cm)	2¼" × 22" (6 × 56cm)	
Front panels	Cut 2.	5" × 44" (13 × 112cm)	5" × 44½" (13 × 113cm)	
Collar bottom	Cut 2.	11" × 23½" (28 × 59.5cm)	11" × 23½" (28 × 59.5cm)	
Collar center backing	Cut 2.	6" × 15" (15 × 38cm)	6" × 15" (15 × 38cm)	
Collar back neck	Cut 1.	11" × 21½" (28 × 54cm)	11" × 23" (28 × 58.5cm)	
Side panels	Cut 2.	2½" × 16½" (6.5 × 42cm)	3¾" × 16½" (9.5 × 42cm)	

■ Construction

▌ STITCH THE KOGIN BACK AND COLLARS

See Before You Stitch (page 30) to learn how to prepare the kogin thread, how to find and mark the center of the fabric, and how to begin stitching.

1. Mark the center point of the evenweave fabrics with contrasting thread.

2. Use our sample motifs or choose your own from the Kogin-zashi Stitch Library. See Substitutes Accepted! (page 123). We used:

- Full Pattern 8 (page 112) for the back panel

- Full Pattern 9 (page 113) for collar 1

- Full Pattern 10 for collar 2 (page 114)

3. Stitch the motif, starting at the center and working outward in both directions.

L	XL	2X	3X	4X	5X
Cut from evenweave:					
13″ × 22″ (33 × 55.8cm)	13″ × 22″ (33 × 55.8cm)	13″ × 22″ (33 × 55.8cm)	13″ × 22″ (33 × 55.8cm)	13″ × 22″ (33 × 55.8cm)	13″ × 22″ (33 × 55.8cm)
6″ × 15″ (15 × 38cm)	6″ × 15″ (15 × 38cm)	6″ × 15″ (15 × 38cm)	6″ × 15″ (15 × 38cm)	6″ × 15″ (15 × 38cm)	6″ × 15″ (15 × 38cm)
Cut from vest fabric:					
16¼″ × 5″ (41 × 13cm)	17¼″ × 5″ (44 × 13cm)	18¼″ × 5″ (46 × 13cm)	19¼″ × 5″ (49 × 13cm)	20¼″ × 5″ (51 × 13cm)	21¼″ × 5″ (54 × 13cm)
16¼″ × 19½″ (41 × 50cm)	17¼″ × 20″ (44.5 × 51cm)	18¼″ × 21″ (46 × 53cm)	19¼″ × 21¾″ (49 × 55cm)	20¼″ × 22½″ (51 × 57cm)	21¼″ × 22¾″ (54 × 58cm)
2¼″ × 22″ (6 × 56cm)	3¼″ × 22″ (8 × 56cm)	3½″ × 22″ (9 × 56cm)	4¼″ × 22″ (11 × 56cm)	4½″ × 22″ (11.5 × 56cm)	5¼″ × 22″ (13 × 56cm)
5″ × 44½″ (3 × 113cm)	5″ × 45″ (13 × 114cm)	5½″ × 46″ (13 × 117cm)	6″ × 46¾″ (15 × 119cm)	6½″ × 47½″ (16.5 × 121cm)	6¾″ × 47¾″ (17 × 121cm)
11″ × 23″ (28 × 58.5cm)	11″ × 23½″ (28 × 59.5cm)	11″ × 23¾″ (28 × 60cm)	11″ × 24¼″ (28 × 61.5cm)	11″ × 25″ (28 × 63.5cm)	11″ × 24¾″ (28 × 63cm)
6″ × 15″ (15 × 38cm)	6″ × 15″ (15 × 38cm)	6″ × 15″ (15 × 38cm)	6″ × 15″ (15 × 38cm)	6″ × 15″ (15 × 38cm)	6″ × 15″ (15 × 38cm)
11″ × 24½″ (28 × 62cm)	11″ × 24½″ (28 × 62cm)	11″ × 26¾″ (28 × 68cm)	11″ × 27½″ (28 × 70cm)	11″ × 27½″ (28 × 70cm)	11″ × 29″ (28 × 74cm)
5¾″ × 16½″ (14.5 × 42cm)	5¾″ × 16½″ (14.5 × 42cm)	6¾″ × 16½″ (17 × 42cm)	7¾″ × 16½″ (20 × 42cm)	8¾″ × 16½″ (22 × 42cm)	8¾″ × 16½″ (22 × 42cm)

▎ ASSEMBLE PIECED SECTIONS

Assemble Back Panel

1. With right sides facing, sew the kogin back to the vest back sides.

2. Sew the vest back top and bottom to the assembled center back.

3. Press seams away from the evenweave. If you are going to fell your seams, do so now!

Assemble Collar Panel

1. With right sides facing, sew the kogin collar insert to the collar center backing along the right long side. Press seams away from evenweave.

2. Repeat for the second collar insert along the left long side.

3. With right sides facing, sew one finished kogin collar piece to the collar back neck. Press the seams.

4. In the same manner, sew the second collar insert to the other end of the collar back neck.

5. With right sides facing, sew 1 collar bottom to the bottom of the assembled collar. Press seams away from the evenweave.

6. Repeat step 5 with the other collar bottom.

7. Fold it in half lengthwise, and press.

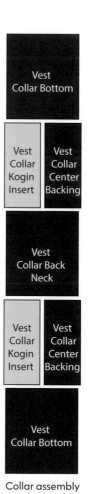

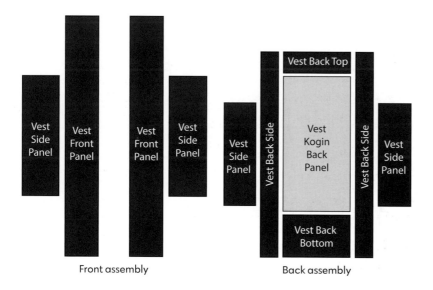

Front assembly Back assembly Collar assembly

▌ BACK NECK DROP AND SHOULDER SLOPE

1. Fold the back panel in half lengthwise and mark the center point.

2. Open the back panel right side up and mark 1″ (25mm) down from the center point just marked. Draw a straight 3″ (7.5cm) line parallel to the top edge of the back neck and centered on the center point mark. Mark the left and right ends of this line.

3. Draw the back neckline measurement from the table below, centered on the center point mark. Mark the left and right ends of this line.

4. On one side only, draw a gentle curve connecting the outside point of the back neckline to the corresponding side of the back neck drop line.

5. Fold the back panel in half lengthwise again, and cut through both layers of fabric along the back neck drop line.

▌*Note: Household Goods*
If you are worried about free-handing this curve and do not have a tailor's curve, grab a plate from the kitchen and use it as a template to help with the curve.

BACK NECKLINE

S	M	L	XL	2X	3X	4X	5X
6½″ (16.5cm)	7″ (18cm)	7½″ (19cm)	7½″ (19cm)	8¼″ (21cm)	8½″ (21.5cm)	8½″ (21.5cm)	9″ (23cm)

Shoulder Slope

BACK PANEL SHOULDER SLOPE

1. On the left and right edges of the back panel, measure down 2″ (5cm) and mark (Mark A).

2. Measure and make a mark 2″ (5cm) from the outside edge of the back neckline (Mark B).

3. Draw a straight line connecting Mark A to Mark B.

FRONT PANEL SHOULDER SLOPE

1. Lay the front panels right side up next to one another as they will be worn.

2. On the left edge of the left front panel, measure down 2″ (5cm) and mark (Mark A).

3. Measure and make a mark 2″ (5cm) from the inside edge of the front panel (Mark B).

4. Repeat Mark A and Mark B on the right front panel.

5. Draw a straight line connecting Mark A to Mark B on each front panel.

❚ ATTACH FRONTS TO BACK

1. With right sides facing, starting from the outside shoulder and, sewing toward the inside edge and back neckline, sew shoulder seams attaching the front panels to the back panel.

2. Press the shoulder seams open. Fell the shoulder seams or cover them, if desired.

❚ ATTACH SIDE PANELS

1. Press and sew ½" (13mm) seams on the top and bottom of both side panels.

2. Referring to the Armhole Depth table (below), measure armhole depth from the shoulder seam and mark the armhole top on both the front and back panels.

3. With right sides facing, pin the side panels to the back panel at the armhole mark and sew.

4. Repeat the process to attach the front panels and side panels.

ARMHOLE DEPTH

S	M	L	XL	2X	3X	4X	5X
8" (20.3cm)	8" (20.3cm)	8½" (21.6cm)	9" (22.9cm)	9½" (24.1cm)	10" (25.4cm)	10½" (26.7cm)	11" (27.9cm)

❚ ATTACH COLLAR

1. With the wrong side facing up, press a ½" (13mm) seam allowance along one long edge and the two short edges of the collar.

2. Press a lengthwise fold down the center of the collar.

3. Sew the short edges down.

4. Fold the collar in half lengthwise and mark the center with a pin or marking pen.

5. Mark the center back of the neckline.

6. Holding the raw (unfolded edge) of the collar to the raw edge of the neckline with the right sides of the fabric facing each other, pin the center mark on the collar to the center mark on the neckline.

7. Working from the center out, pin the rest of the collar in place.

8. Sew the first side of the collar into place.

Tip: Easy Does It!

When sewing the collar into place, sew just like you pinned—from the center out—to ensure the collar lays evenly along the neckline.

9. Press the seam to the vest side.

10. Fold the collar in half lengthwise along the pressed line so the right side is facing out.

11. Pin the collar into place, encasing the first seam. Sew a ¼″ (6mm) seam down the front inside edge of the front panel that was previously pressed.

Note: Stitching on the Edge
We like using an edge stitch foot for this process as you can keep your seam super straight with it.

12. Sew the bottom edge of the collar closed using a blind hem or slip stitch.

█ FINAL TOUCHES

Wear with pride ... a lot of it!

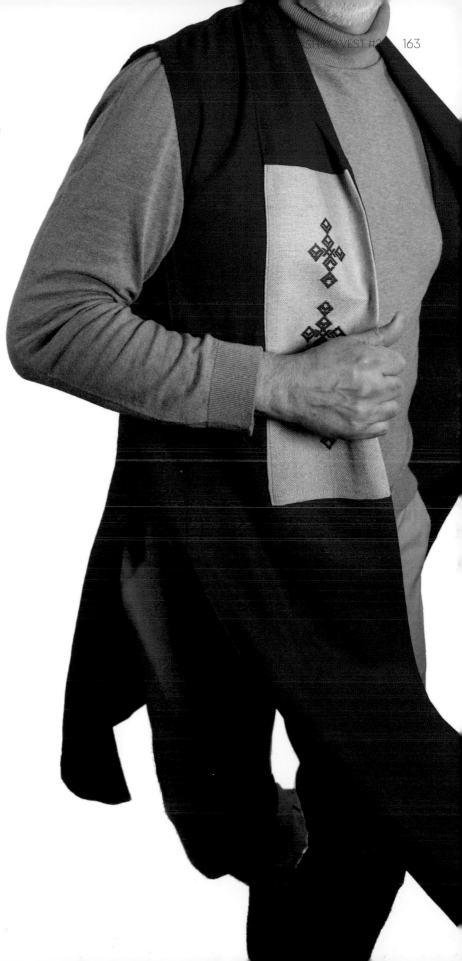

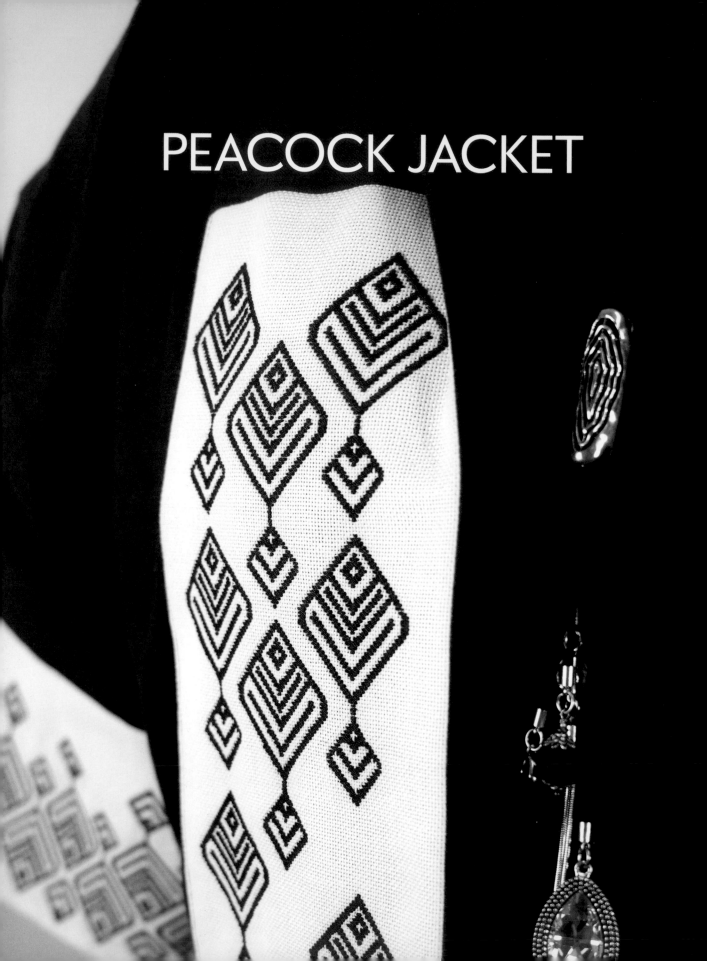

PEACOCK JACKET

THE STITCH PATTERN FOR THIS JACKET IS OUR ORIGINAL DESIGN, inspired by the tail feathers of a peacock, to adorn the back, cuffs, and extra-wide collar panel. The jacket pattern itself is inspired by a traditional Japanese jacket meant for everyday wear. We have altered the original pattern style to include customizations like a rounded back neckline and a shoulder slope for a more comfortable fit and an oversized collar for flair. You can alter the length of the sleeves and the body panels for a unique garment to fit your body and your style.

Size	S	M	L	XL	2X	3X	4X	5X
Measured bust: inches (cm)	32 (81.3)	36 (91.4)	40 (101.6)	44 (111.8)	48 (121.9)	52 (132.1)	56 (142.2)	60 (152.4)
Finished bust: inches (cm)	34 (86.4)	38 (96.5)	42 (106.7)	46 (116.8)	50 (127.0)	54 (137.2)	58 (147.3)	62 157.5)

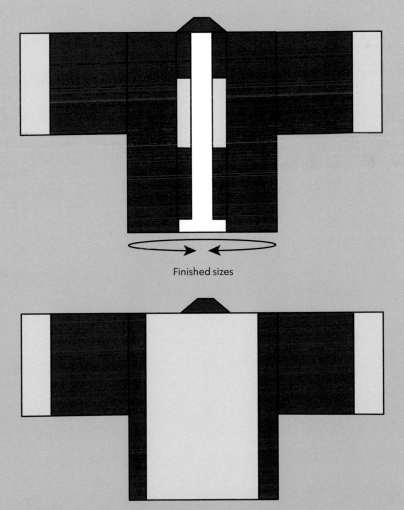

Finished sizes

Materials

Linen or other fabric: 2 (2¼, 2¼, 2¼, 2½, 2½, 2½, 2½) yards / 2 (2.25, 2.25, 2.25, 2.5, 2.5, 2.5, 2.5) m for the jacket. We used Robert Kaufman Brussels Washer Linen in Dark Purple.

Evenweave: 1 (1, 1, 1, 1½, 1½, 2, 2) yards / 1 (1, 1, 1, 1.5, 1.5, 2, 2)m, 20-count Lugana in Antique White.

Aurifil 12-weight cotton thread: We used Aurifil 12-weight, 1240 Very Dark Eggplant.

Kogin sashiko needle and palm thimble (pages 15–16)

Sewing machine and machine thread to match jacket fabric. We use Aurifil 50-weight thread in 1240 Very Dark Eggplant.

Pattern Notes

• *It may be beneficial to highlight your size throughout the pattern before measuring and cutting.*

• *All seam allowances are ½″ (13mm) unless otherwise noted.*

• *Finish all sashiko stitching on individual components before sewing/overlocking the garment together.*

• *This jacket is not lined. To keep internal seams from fraying, we recommend surging/overlocking the body pieces using a 3-needle overlock or a machine overcast/zigzag stitch along the edge. If you are hand sewing, overcast the raw edges to prevent fraying. We opt to use a modified French seam (page 168) for unlined garments.*

• *Left and right sides refer to the placement when worn.*

• *When sewing evenweave to other fabrics, press the seam allowance away from the evenweave whenever possible.*

• *Once seams are pressed open or to the side, you can fell them using a topstitch or a prick stitch to secure them further.*

Cutting

See Before You Stitch (page 30) to learn how to prepare fabric, how to cut evenweave using a thread pull, and how to overcast edges.

Cut components according to the sizes in the cutting chart (below) and overcast all edges to reduce fraying (page 26).

Name	Quantity	S	
Cut from evenweave:			
Kogin back	Cut 1.	16½″ × 27″ (41.9 × 68.5cm)	
Kogin collar insert	Cut 1.	7″ × 15″ (17.8 × 38.1cm)	
Kogin cuff	Cut 2.	8″ × 28″ (20.3 × 71cm)	
Cut from jacket fabric:			
Center back top and bottom	Cut 2.	2⅛″ × 27″ (5 × 68.5cm)	
Back sides	Cut 2.	2″ × 27″ (5 × 68.6cm)	
Front panels	Cut 2	7″ × 27″ (17.8 × 68.6cm)	
Right collar bottom	Cut 1.	6½″ × 13″ (16.5 × 33cm)	
Right collar center backing	Cut 1.	7″ × 15″ (17.8 × 38.1cm)	
Collar back neck	Cut 1.	21½″ × 13″ (54.6 × 33cm)	
Left front collar	Cut 1.	20½″ × 13″ (52 × 33cm)	
Main sleeve	Cut 2.	8″ × 28″ (20.3 × 71cm)	

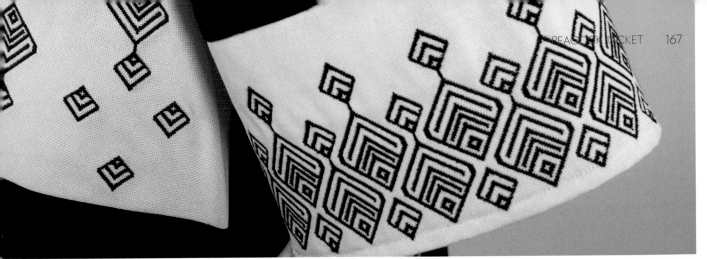

M	L	XL	2X	3X	4X	5X
Cut from evenweave:						
16½" × 27½" (41.9 × 70cm)	20½" × 28" (52 × 71cm)	20½" × 28½" (52 x72cm)	24½" × 29" (62.2 × 74cm)	24½" × 29½" (62.2 × 75cm)	28½" × 30" (72.3 × 76cm)	28½" × 30½" (72.3 × 77.5cm)
7" × 15" (17.8 × 38.1cm)	7" × 15" (17.8 × 38.1cm)	7" × 15" (17.8 × 38.1cm)	7" × 15" (17.8 × 38.1cm)	7" × 15" (17.8 × 38.1cm)	7" × 15" (17.8 × 38.1cm)	7" × 15" (17.8 × 38.1cm)
8" × 28" (20.3 × 71cm)	8" × 28" (20.3 × 71cm)	8" × 28" (20.3 × 71cm)	8" × 30" (20.3 × 76cm)	8" × 30" (20.3 × 76cm)	8" × 32" (20.3 × 81.3cm)	8" × 32" (20.3 × 81.3cm)
Cut from jacket fabric:						
2⅜" × 27½" (6 × 70cm)	2⅝" × 28" (6.5 × 71cm)	2⅞" × 28½" (7 × 72cm)	3⅛" × 29" (8 × 74cm)	3⅜" × 29½" (8.5 × 75cm)	3⅝" × 30" (9 × 76cm)	3⅞" × 30½" (10 × 77.5cm)
3" × 27½" (7.6 × 69.9cm)	2" × 28" (5 × 71.1cm)	3" × 28½" (7.6 × 72.4cm)	2" × 29" (5 × 73.7cm)	3" × 29½ (7.6 × 74.9cm)	2" × 30" (5 × 76.2cm)	3" × 30½ (7.6 × 77.5cm)
7¾" × 27½" (19.7 × 69.9cm)	8½" × 28" (21.6 × 71.1cm)	9½" × 28½" (24.1 × 72.4cm)	10½" × 29" (26 × 73.7cm)	11" × 29½" (27.9 × 74.9cm)	12" × 30" (30.5 × 76.2cm)	12½" × 30½" (31.8 × 77.5cm)
6½" × 13" (16.5 × 33cm)	6½" × 13" (16.5 × 33cm)	7" × 13" (17.7 × 33cm)	6¾" × 13" (17 × 33cm)	7" × 13" (17.7 × 33cm)	7½" × 13" (19 × 33cm)	7½" × 13" (19 × 33cm)
7" × 15" (17.8 × 38.1cm)	7" × 15" (17.8 × 38.1cm)	7" × 15" (17.8 × 38.1cm)	7" × 15" (17.8 × 38.1cm)	7" × 15" (17.8 × 38.1cm)	7" × 15" (17.8 × 38.1cm)	7" × 15" (17.8 × 38.1cm)
23" × 13" (58.4 × 33cm)	24½" × 13" (62.2 × 33cm)	24½" × 13" (62.2 × 33cm)	26¾ x13" (68 × 33cm)	27½" × 13" (69.8 × 33cm)	27½" × 13" (69.8 × 33cm)	29" × 13" (73.6 × 33cm)
20½" × 13" (52 × 33cm)	20½" × 13" (52 × 33cm)	21" × 13" (53.3 × 33cm)	20¾" × 13" (52.7 × 33cm)	21" × 13" (53.3 × 33cm)	21½" × 13" (54.6 × 33cm)	21½" × 13" (54.6 × 33cm)
8¾" × 28" (22.3 × 71cm)	9" × 28" (22.8 × 71cm)	9¼" × 28" (23.5 × 71cm)	9½" × 30" (24.1 × 76cm)	9¾" × 30" (24.7 × 76cm)	10" × 32" (25.4 × 81.3cm)	10" × 32" (25.4 × 81.3cm)

■ Construction

STITCH THE KOGIN BACK, COLLAR INSERT, AND CUFF

See Before You Stitch (page 30) to learn how to prepare the kogin thread, how to find and mark the center of the fabric, and how to begin stitching.

1. Mark the center point of the evenweave fabric with contrasting thread.

2. Use our sample motifs or choose your own from the Kogin-zashi Stitch Library. See Substitutes Accepted! (page 123). We used:

- Full Pattern 11 / Peacock Jacket Back Panel (pages 115–118)

- Full Pattern 12 / Peacock Jacket Collar (pages 119–120)

- Full Pattern 13 / Peacock Jacket Cuff (page 121)

See Breaking It Down (page 43) to learn how to use repeat charts to stitch the large motif for the back.

3. Stitch the motifs, starting at the center and working outward in both directions.

- -

ENCASED SEAMS: MODIFIED FRENCH SEAM

When working with fabric with edges that fray easily like evenweave or linen, sewing encased seams will eliminate fraying, protect the seam from wear against the body, and give your overall garment a polished look. This is especially true of garments that are not lined.

Unlike the standard French seam, we are not trimming off the overlocked edge in step 4. Instead of trimming, we *add* ⅛″ to the second seam to totally encase the first. This is different from the way you might have learned a French seam, but we like the results.

1. Add ¼″ to the cut measurement to the side of each piece where you will be sewing the encased seam.

2. Pin the wrong sides of the fabric together and sew a ¼″ seam. The seam allowance will end up on the right side of the fabric; this is the opposite of a standard seam.

3. Press the seam flat to one side.

4. Fold the fabric along the seam line, so the right sides of the fabric are facing. Press well.

5. With right sides of the fabric facing, sew a second seam ⅜″ in from the folded edge.

▌ *Note: IMPORTANT*
Be sure this seam completely encases the first seam—nothing is not encased, any extra will show on the right side of the item.

6. From the wrong side, press the final seam to the side furthest from the garment front.

Optional: If desired, topstitch the seam to keep it flat and add a little extra detail to the finished garment.

▌ ASSEMBLE PIECED SECTIONS

Assemble Back Panel

1. With right sides facing, sew the kogin back panel to the jacket top and bottom back panels. Press seams away from the evenweave.

2. Sew the jacket sides to the assembled center back.

3. Press seams away from the evenweave. If you are going to fell your seams, do so now!

Back assembly

Assemble Collar Panel

1. With the right sides facing, sew the kogin collar insert to the collar center backing along the right long side. Press seams away from the evenweave.

2. With right sides facing, sew the finished kogin collar to the right side of the collar back neck. Press the seams.

3. In the same manner, sew the left front center to the other end of the collar back neck. Press the seams.

4. With right sides facing, sew the collar bottom to the kogin piece of the assembled collar. Press seams away from the evenweave.

5. Fold in half lengthwise and press.

Collar assembly

Assemble Sleeve Panel

1. With right sides facing, sew the kogin cuff to each sleeve. Press seams away from the evenweave.

▌BACK NECK DROP

Follow the Back Neck Drop directions (page 161) in the Sashiko Vest #2 chapter to mark and cut a back neck curve for your size.

▌ATTACH FRONTS TO BACK

1. Right sides facing, starting from the outside shoulder and sewing toward the inside edge and back neckline, sew shoulder seams attaching the front panels to the back panel.

2. Press shoulder seams open or fell to one side. Again, we used a modified French seam (page 168) for added strength.

Front/back assembly

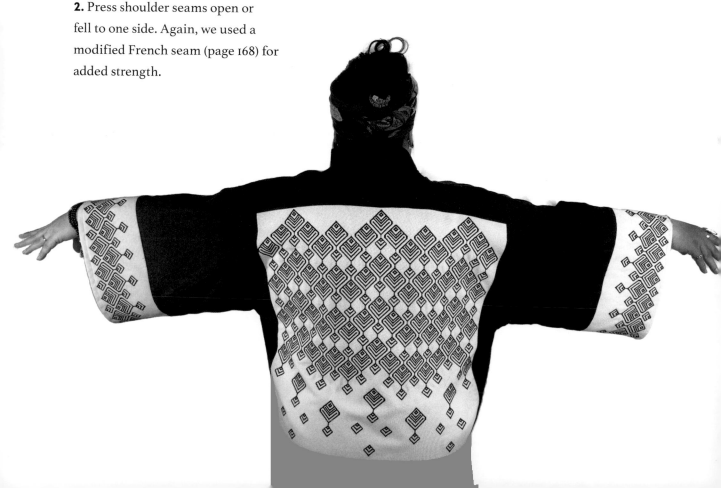

ATTACH SLEEVES

1. Lay the garment body open with the right side facing up.

2. Set in the sleeves as follows:

 a. Fold the sleeve in half lengthwise and mark the center of the sleeve.

 b. Match the center mark on the sleeve to the shoulder seam and pin it into place.

 c. Continue to pin well along the seam.

3. Sew the sleeve to the body of the jacket.

4. Repeat with the second sleeve.

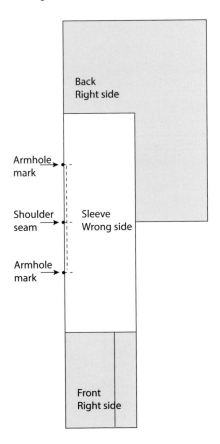

SEW UNDERSIDE OF SLEEVE AND SIDES

1. Turn the jacket inside out so the right side of the sleeve and the body of the jacket are facing each other.

2. Pin the side seams of the jacket body together.

3. Pin the underside seam of the sleeves together.

4. Starting from the bottom of the garment, sew the side seam up to the sleeve opening.

5. Continue to sew along the bottom seam of the sleeve to the cuff.

6. Repeat for the second sleeve.

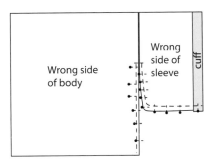

FINISH SLEEVE CUFFS

1. With the wrong side of the sleeve facing up, press a ½″ (13mm) hem along the cuff.

2. Fold and press another 1″ (2.5cm) hem allowance along the cuff.

3. Sew the folded hem, using a blind hem stitch to secure the seam.

4. Repeat for the second sleeve.

▊ ATTACH COLLAR

1. Fold the collar in half lengthwise and press.

2. With the wrong side facing up, press a ½″ (13mm) seam allowance along the long edge with the kogin panels.

3. Fold the collar in half crosswise and mark the center with a pin or marking pen. This is the center back neck of the collar.

4. Mark the center back of the neckline.

5. Holding the raw (unfolded edge) of the collar to the raw edge of the neckline with the *right sides* of the fabric facing each other, pin the center mark on the collar to the center mark on the neckline.

6. Working from the center out, pin the rest of the collar in place.

7. Sew the first side of the collar into place.

> ### Tip: Easy Does It!
> When sewing the collar into place, sew just like you pinned—from the center out—to ensure the collar lays evenly along the neckline.

8. Press the seam toward the collar.

9. Fold the collar in half lengthwise along the pressed line so the *right* side is facing out and ½″ seam covers the seam just sewn. This will encase the front edge of the raw seam.

10. Pin the collar into place being careful to pin the collar flat so as not to skew the two sides of the collar while sewing.

11. Topstitch a ¼″ (6mm) along folded edge sewing through ½″ (13mm) folded seam and raw seam.

▊ BOTTOM HEM

1. With the wrong side facing, fold and press a ¼″ (6mm) hem along the entire bottom hem including the collar panel.

2. Fold and press another 1″ (2.5cm) hem encasing the previous ¼″ (6mm).

3. Pin into place and sew around the bottom hem using a blind hem stitch to secure the seam.

▊ FINAL TOUCHES

Wear with pride … a lot of it!

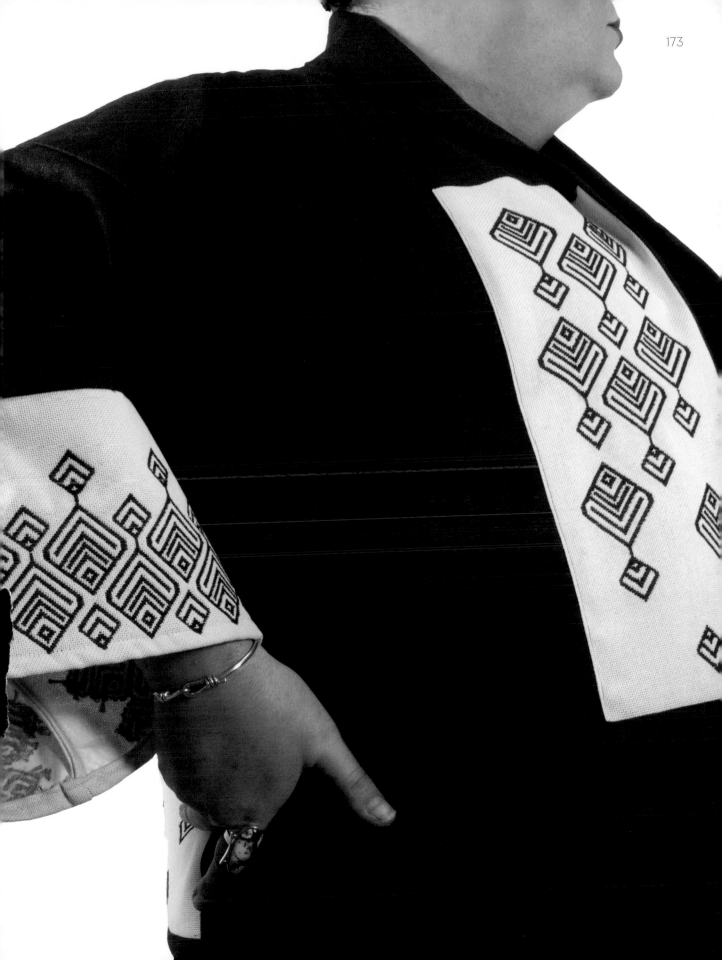

Bibliography

Hirosaki Kogin Institute. *Tsugaru Kogin-zashi: Techniques and Designs*. Japan: Seibundo Shinkosha Publishing Co., Ltg, 2013.

Maiko Ishida. *Dreaming Kogin*. Japan: Grail Books, November 30, 2019.

Tsugaru Kogin. *Working Clothes are Beautiful* (translated). Japan: LIXIL Publishing, September 20, 1998.

Textile Research Center. "Kogin Zashi." Last modified October 1, 2016. trc-leiden.nl/trc-needles/regional-traditions/east-asia/japan/kogin-zashi

Hirosaki Kogin Institute (official site)

tsugaru-kogin.jp/en/

KoginBank

koginbank.com/en/

Kogin.net

kogin.net

Caulfeild, Sophia Frances Anne., Saward, Blanche C. *The Dictionary of Needlework: An Encyclopaedia of Artistic, Plain, and Fancy Needleworks*. United Kingdom: L. Upcott Gill, (n.d.).

T.V. Kara-Vasilieva., *Poltava Folk Embroidery*. Scientific Thought Publishing House, 1983

Bethany J. Walker. "Rethinking Mamluk Textiles." Middle East Documentation Center. The University of Chicago, 2000.

About the Authors

SHANNON LEIGH ROUDHÁN AND JASON BOWLSBY are the dynamic DIY duo from Seattle, Washington. Their award-winning crochet, knit, and sewing designs have been featured in and on the covers of domestic and international publications, and their craft, portrait, and fashion photography have appeared in books and magazines around the globe. Shannon and Jason have published 10 books of crochet and knitwear patterns including *Complete Crochet Course—the Ultimate Reference Guide*, *Designer Crochet*, and *Crochet Geometry*. Their latest book is *Boro & Sashiko: Harmonious Imperfection* from C&T Publishing.

The duo have been partners in life for 27 years and have been teaching adults for 20+ years. With their mastery of subjects from crochet and knitting to photography, spinning, sewing, and quilting, their enthusiasm, quirky senses of humor, and relatable teaching style have made them sought-after teachers in both local and national venues such as Sew Expo, Houston Quilt Festival, Pacific International Quilt Festival, and the Bainbridge Artisan Resource Network (BARN). They also have a wide range of online classes available from Craftsy and Creative Spark Online. The "edutainment" experience of a class with Shannon and Jason will leave you informed, empowered, and in stitches (see what we did there?).

Jason and Shannon

Website: shannonandjason.com/
Instagram: /embracethecreativechaos/
Twitter: /ShannonandJason
Facebook: /embracethecreativechaos/

Other books by the authors: